STARLIT WATERS

BRITISH SCULPTURE
AN INTERNATIONAL ART 1968–1988

LANSDOWN

The Trustees and Director are indebted to the Merseyside Development Corporation for their major contribution and to the following for their generous financial support:

CAPITAL COSTS OF
TATE GALLERY LIVERPOOL

Founding Benefactor
The Wolfson Foundation

Founding Patrons
The John S Cohen Foundation
The Esmee Fairbairn Charitable Trust
Granada Television and Granada Foundation
The Henry Moore Foundation
The Moores Family Charitable Foundation
The New Moorgate Trust Fund
Ocean Transport and Trading plc (P H Holt Charitable Trust)
Plessey Major Systems, Liverpool
The Sainsbury Family Charitable Trusts
The Bernard Sunley Charitable Foundation

Other Major Supporters
Arrowcroft Group Ltd
Barclays Bank plc
The Baring Foundation
Deloitte Haskins and Sells
Higsons Brewery plc
The John Lewis Partnership
The Liverpool Daily Post and Echo Ltd
The Manor Charitable Trust
The Pilgrim Trust
Pilkington plc
The Eleanor Rathbone Charitable Trust
Royal Insurance UK and Royal Insurance plc
Trustee Savings Bank Foundation
United Biscuits UK Ltd
Whitbread & Co plc

Contributions have also been received from
The Beausire Trust
Blankstone Sington and Company
British Gas plc
Commercial Union Assurance Company plc
GMB
The Goldsmiths' Company
The Grocers' Company
Mrs Sue Hammerson
ICI
The Idlewild Trust
J P Jacobs
Kodak Ltd
The Members of Lloyd's and Lloyd's Brokers
Sir Jack and Lady Lyons
Mason Owen and Partners
The Mercer's Company
Provincial Insurance
The Rogot Trust
Royal Bank of Scotland plc
Schroder Charity Trust
John Swire and Sons Ltd
The Twenty-Seven Foundation
Vernons Organisation Ltd
An anonymous donor

SPONSORS OF
TATE GALLERY LIVERPOOL 1988 – 9
Andrews Industrial Equipment Ltd
Ashton-Tate plc
Ivor Braka Ltd
British Rail
Bymail
DDB Needham Worldwide
Fraser Williams Group
Granada Business Services
Greenall Whitley plc
The Henry Moore Foundation
IBM United Kingdom Trust
ICI Chemicals and Polymers Limited
The Laura Ashley Foundation
Merseyside Task Force
MoMART
Mont Blanc
P & P Micros Ltd
Patrons of New Art,
Friends of the Tate Gallery
Parkman Consulting Engineers
Pentagram Design Limited
Tate Gallery Foundation
Tate Gallery Publications
Tate Gallery Restaurant
Thames and Hudson Ltd
Save and Prosper
Unilever plc
Volkswagen

CONTENTS

SPONSOR'S FOREWORD

ICI Chemicals & Polymers are delighted to be associated with the opening of the Tate Gallery Liverpool, and in particular with its inaugural exhibition, *Starlit Waters*.

Starlit Waters illustrates the work of innovative artists using material and developing ideas and concepts which breech traditional boundaries of sculpture. The artists concerned have won international recognition and gained acclaim for their work both at home and abroad.

For many years ICI has been a major employer in the North West of England and that is a role it endeavours to undertake in a responsible manner. An important element that emerges from this attitude is that of encouraging sports, the arts and local community initiatives.

With ongoing commitments to the Mersey Basin Campaign, local sport – in various guises – and the Royal Liverpool Philharmonic Orchestra, the added sponsorship of *Starlit Waters* enables us to contribute effectively towards a cohesive programme within the North West community.

We trust that this sponsorship will adequately promote the talents and skills of the artists concerned throughout the North West of England and beyond.

R I Lindsell
Chief Executive
ICI Chemicals and Polymers

DIRECTOR'S PREFACE

There can be no doubt about the international importance of British sculpture throughout the twentieth century. As generation has followed generation, so group after group of sculptors has come forward, to attract admiration at home and abroad. The remarkable reputation of Henry Moore, as one of the most universal of all twentieth century artists, is the confirmation of this phenomenon.

Starlit Waters focuses attention, for the first time in this country, on the new group of British sculptors who emerged in the late 1970s and early 1980s. Their subjects and their materials differ substantially from the abstract metal sculptures of the 1960s. Yet this is only the continuation of a dialectic, an argument about the nature and meaning of sculpture, to which no other country is contributing more.

This exhibition brings together the work of 18 sculptors, almost all of them in their thirties and forties. Several came to this country to study, and have remained here to work. Others, British born, have spent much of their working lives abroad; there is no common style, but a community of purpose links them together. Some of the works displayed have been purchased for the Tate Gallery collection: others have been lent to the exhibition.

The venue of the Albert Dock, as rebuilt to the plans of James Stirling, seems particularly appropriate. Much of the sculpture has been made in converted warehouse buildings, and Tate Gallery Liverpool uses one of the grandest of them all as a museum of modern art.

Major support for the exhibition has been received from two sources. ICI Chemicals and Polymers Limited have for the first time given significant sponsorship for the visual arts. We welcome their initiative.

The exhibition has also been sponsored by the Henry Moore Foundation, to which the Tate Gallery is once again deeply grateful. Founding Patrons of the Tate Gallery Liverpool, the Henry Moore Foundation has for some years been supporting sculpture conservation at the Tate. This has in turn helped to make possible the next major display of work at the Tate Gallery Liverpool, that of British sculpture 1908–88, almost all from the permanent collection of the Tate, which follows the *Starlit Waters* exhibition. The Henry Moore Foundation also supports the Henry Moore Centre for the study of sculpture in Leeds, and with the Yorkshire Sculpture Park at Wakefield, the North of England can now boast rich collections of this most successful of British visual arts.

Finally, it remains only for me to thank on behalf of the Trustees all those who have most generously lent to the exhibition, and in particular the sculptors themselves for their support and collaboration. Without them nothing would have been possible.

Sir Alan Bowness
Director
Tate Gallery

It is ironical that the greatest contributions to sculpture in Britain in the twentieth century have been made by foreigners – Gaudier-Brzeska, Epstein, Gabo – or British artists thoroughly steeped in foreign influences – Moore, Hepworth, Caro. It has been nevertheless Britain's receptive insularity that has made it possible, despite the lack of a strong native tradition, to promulgate a history of British sculpture.

This sense of insularity changed in the 1960s. Prosperity, tertiary education, cheaper travel and advanced communications in the developed countries produced an unprecedented internationalism. Theatre, music, dance, film and the visual arts were particularly imbued with the cosmopolitanism of what was crudely called 'the swinging sixties'. Artists and musicians felt themselves to be part of an international, or, better, supra-national community, whose audience was potentially worldwide. Although a number of artists continued to nourish their work through its association with a particular place, (Richard Long's with the River Avon, or Ian Hamilton Finlay's with Little Sparta) their practice was compatible with an international outlook and was moreover consciously outside any native tradition. It is this spirit that has given the art shown in *Starlit Waters* its widespread appeal and continued success, especially outside the shores of Britain.

Over the last decade, curators in many European countries, in Japan, Australia and in the USA, have made popular exhibitions of aspects of contemporary British sculpture. The work of a number of artists is now more familiar abroad than at home. *Starlit Waters* is a distillation from these exhibitions, the first in this country, taking the perspective of an international public. The selection has been made with an eye to the best individual works, concentrating on the most widely and consistently successful artists. Had there been space enough the exhibition would have acknowledged the supra-national by gathering the best sculptures of 'Western Art' of the last twenty years, but space being limited we have given priority in this inaugural exhibition to 'British' art. Appropriately for a gallery concerned with the whole of modern art, the exhibition is also retrospective: historical rather than exploratory.

In fact it focuses rather narrowly on the artists associated with the 'Vocational Sculpture Course' run by Frank Martin at St Martin's School of Art in London in the late 1960s, (Bruce McLean, Barry Flanagan, Richard Long, Hamish Fulton, John Hilliard) and on sculptors showing at the Lisson Gallery from the early 1980s (Tony Cragg, Richard Deacon, Shirazeh Houshiary, Anish Kapoor, Richard Wentworth, Bill Woodrow). It also pays tribute to the essential catalytic role played by the work of John Latham, Ian Hamilton Finlay, Art and Language, William Tucker and Michael Craig-Martin.

These two fields on which it focuses had first been explored by, respectively, *The New Art* (Arts Council of Great Britain, Hayward Gallery, London, 1972), and *Objects and Sculpture* (simultaneously at Arnolfini Gallery,

Barry Flanagan
Leaping Hare with Crescent and Bell 1983

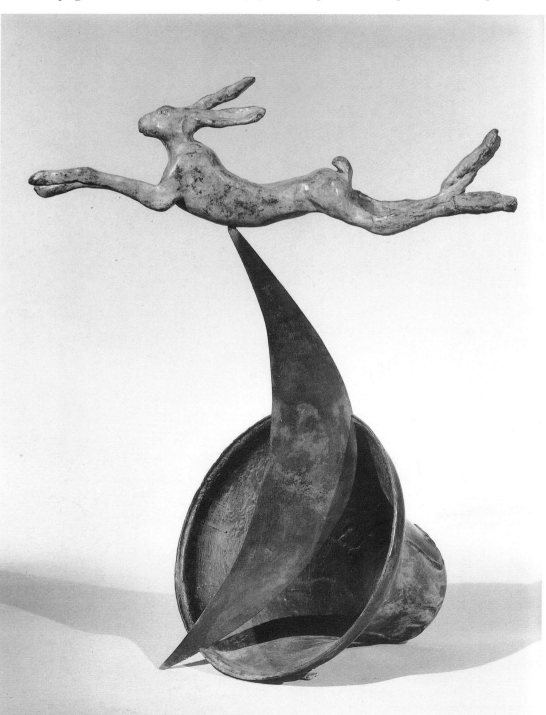

6

Bristol, and ICA, London, 1981). The first exhibition to attempt to review the period in question was *Kunst in Europa Na '68* (Gent 1980)[1]. This was of course a European-wide exhibition, and included only Tony Cragg of the younger British artists.

There have been several exhibitions in the last five years to undertake the same recapitulation, but none in this country[2]. *Between Object and Image* (Ministry of Culture, Madrid, with the British Council, 1986) emphasised the sculpture of the 1980's, introducing the context of major figures from the previous two generations to illustrate the themes of conceptualism and objecthood. *A Quiet Revolution* (Museum of Contemporary Art, Chicago, and San Francisco Museum of Modern Art, 1987) was a direct precursor of *Starlit Waters,* in presenting the two 'generations' with their 'distinct directions and shared continuities'[3]. While *A Quiet Revolution* showed only six artists' work, however, *Starlit Waters* includes works by eighteen.

Very different critical receptions, in so far as one can generalise, were given the first and second groupings shown here. The artists in the second have had to wait until their early 30s to receive the same measure of international renown given the first soon after leaving art school. This is perhaps also a measure of the novelty of the 'internationalism' of the sixties: the second group has had to conquer ground already occupied.

Britain has sometimes been slow to recognise, and even slower to support her own artists, and not only in the visual arts: the Beatles made their reputation in Germany. Of the 40 'selected exhibitions' listed in the catalogue of *The New Art* as being relevant to this exhibition, only six originated in Britain. Richard Long had been invited to make 10 solo exhibitions in other countries before his first in Britain (at the Museum of Modern Art in Oxford in 1971). The second group have fared better as prophets in their own land, but we in this country are still slow to recognise what other nations perceive quickly and clearly: that Britain has continued to provide conditions and the talent for the creation of art of world importance. We trust that this first exhibition at Tate Gallery Liverpool showing the high achievements of the last twenty years will find a public as enthusiastic as that which has welcomed these artists in so many other countries.

Richard Francis
Curator
Tate Gallery Liverpool

Lewis Biggs
Curator, Exhibitions and Displays
Tate Gallery Liverpool

"Nature is the Devil in a fancy waistcoat".
Samuel Taylor Coleridge

Translation for our time:
"Nature is a storm trooper in a camouflage smock".

Ian Hamilton Finlay

Ian Hamilton Finlay
Osso 1987
Note: *Osso,* Italian, *Bone*

Ian Hamilton Finlay
4 Sails 1967

NOTES:

1. A number of important exhibitions organised by the British Council drew together sculpture of the 1960s and 1970s (*Arte Inglese Oggi*, Milan 1976; *Un Certain Art Anglais*, Paris, 1979; for instance) but evidently could not contain work by the artists who have come to prominence in the 1980s.

2. *The Sculpture Show*, Serpentine and Hayward Galleries, London, 1983, was a compendium of work by 50 contemporary sculptors, selected by three people independently, and included a number of artists with little experience of public exposure.

3. Introduction, page 8.

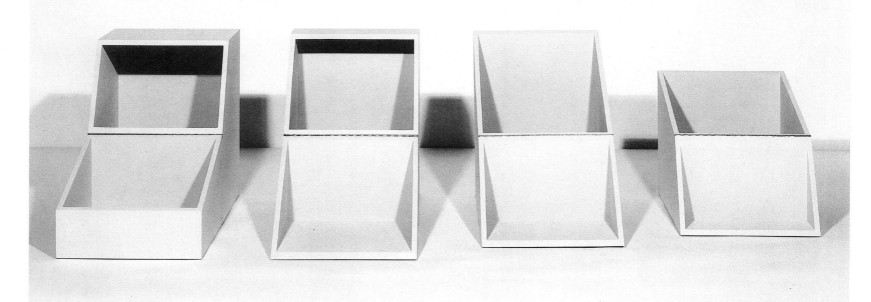

Michael Craig-Martin
Drawing for four Identical Boxes with Lids Reversed 1969

Michael Craig-Martin
8 *Four Identical Boxes with Lids Reversed* 1969

Michael Craig-Martin
Reading (with Globe) 1980

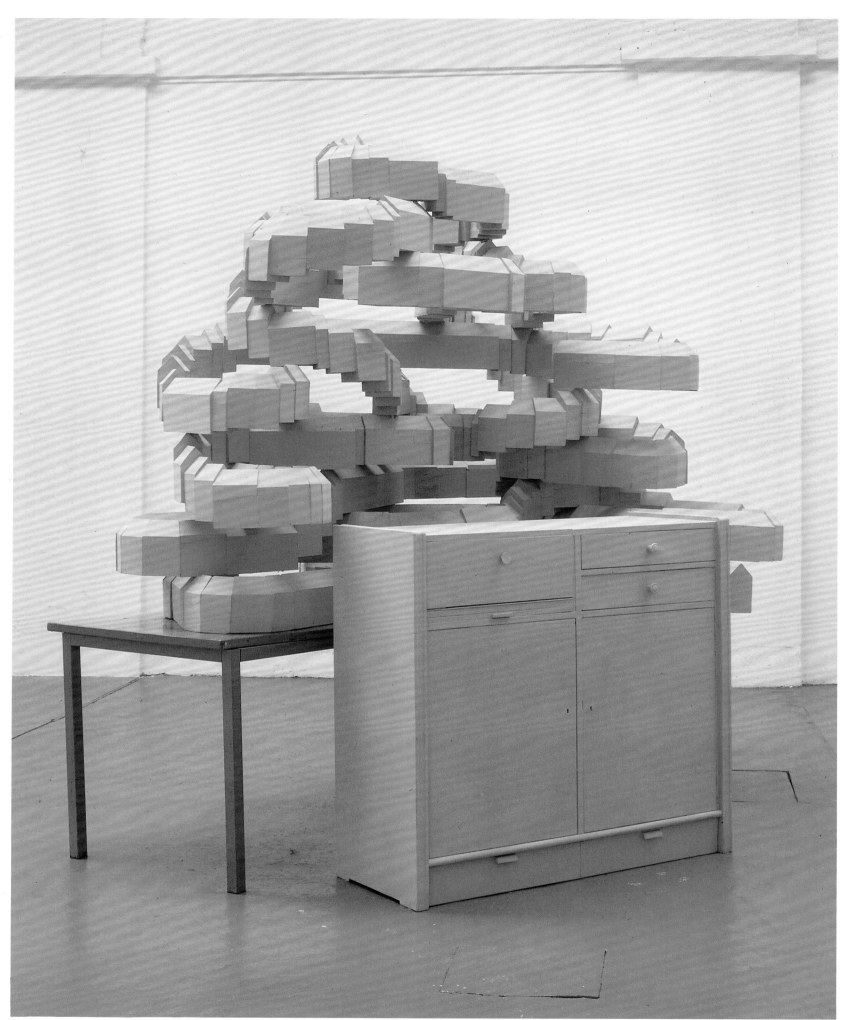

Tony Cragg
10 Città 1986

Tony Cragg
Mollusc 1987

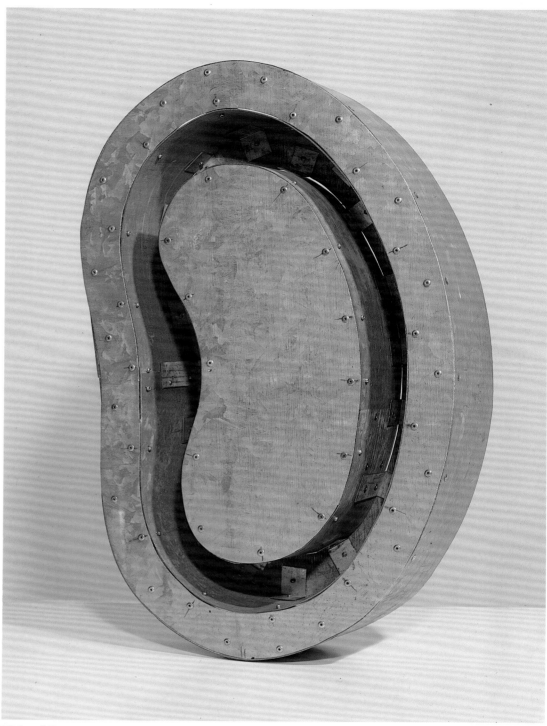

Richard Deacon
Art for Other People #9 1983

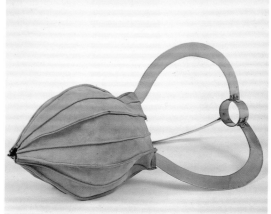

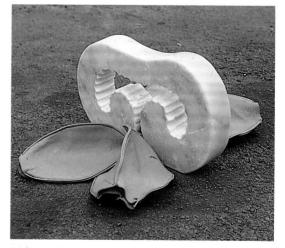

Richard Deacon
12 *Art for Other People #8* 1985

Richard Deacon
Art for Other People #6 1983

Richard Deacon
Art for Other People #12 1984

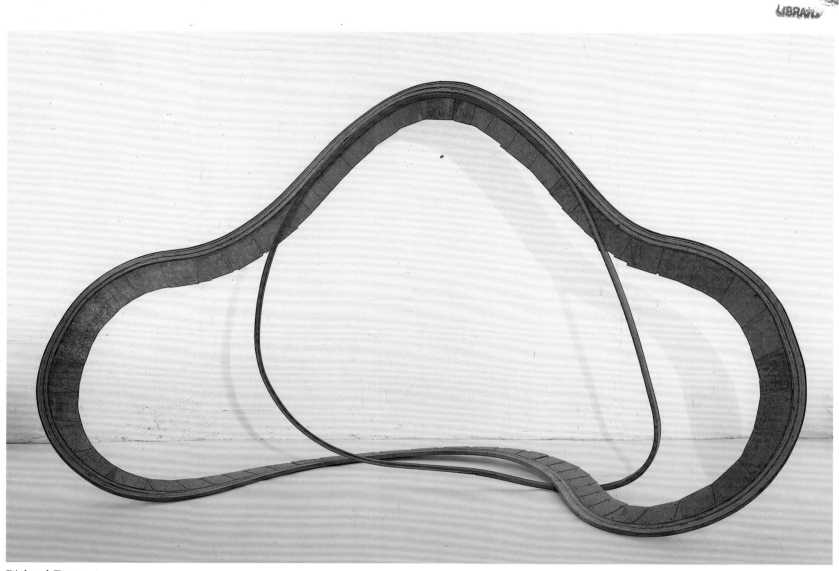

Richard Deacon
For Those Who Have Ears #1 1983

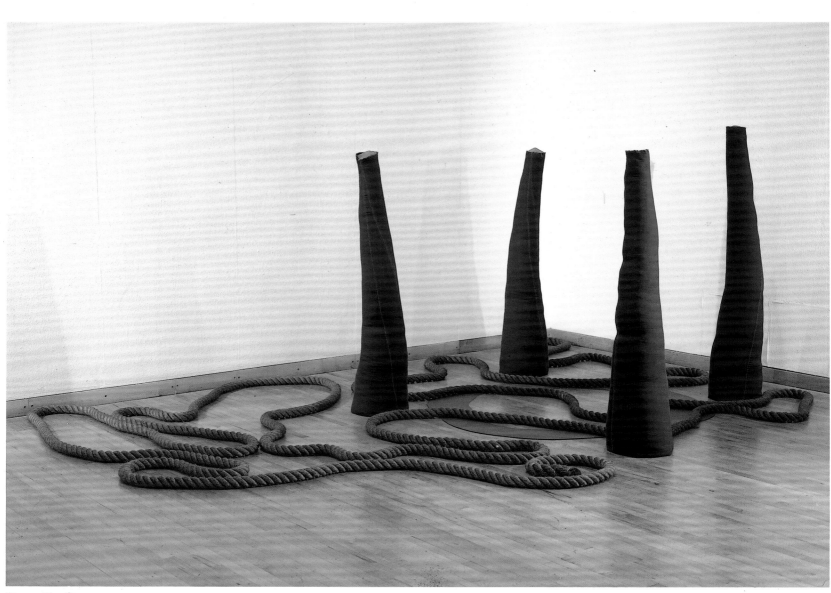

Barry Flanagan
Four Casb 2 '67, Rope (Gr 2sp 60) 6 '67 Ring 1 '67, 1967

Barry Flanagan
Sixties' Dish 1970

WHITE CLOUD

A FOURTEEN AND A HALF DAY WALKING JOURNEY OF APPROXIMATELY 200 MILES

TRAVELLING BY WAY OF RINGDOM GOMPA THE PENZI PASS THE ZANSKAR VALLEY ATING GOMPA HUTTRA

THE MUNI GLACIER MACHAIL AND THE CHANDER BHAGA RIVER NORTHERN INDIA JULY 1978

R O C K

P A T H

A TWELVE DAY WALKING JOURNEY IN LADAKH CROSSING TWELVE MOUNTAIN PASSES

FROM LAMAYURA TO DRAS INDIA JULY 1984

Antony Gormley
Bed 1980–81

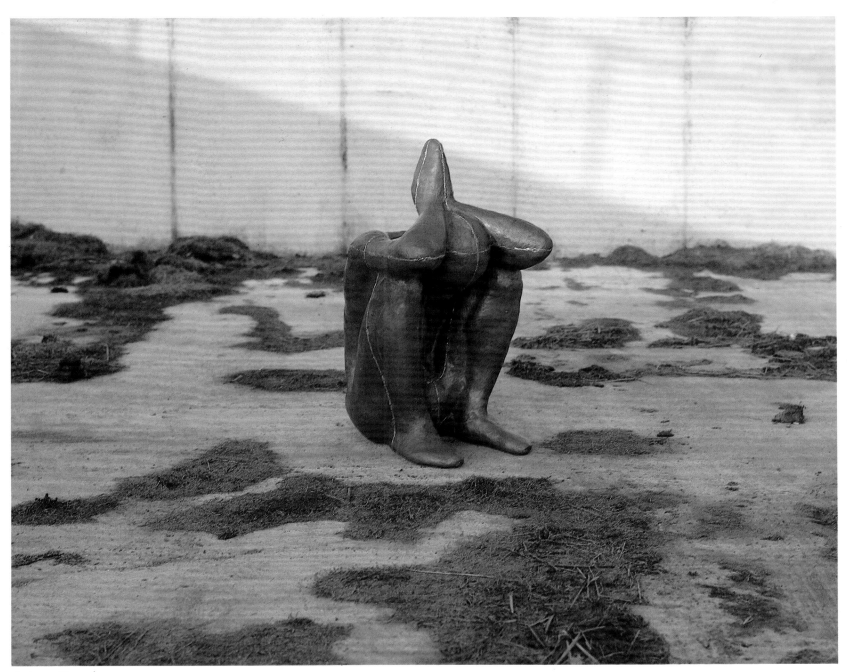

Antony Gormley
Hold 1986

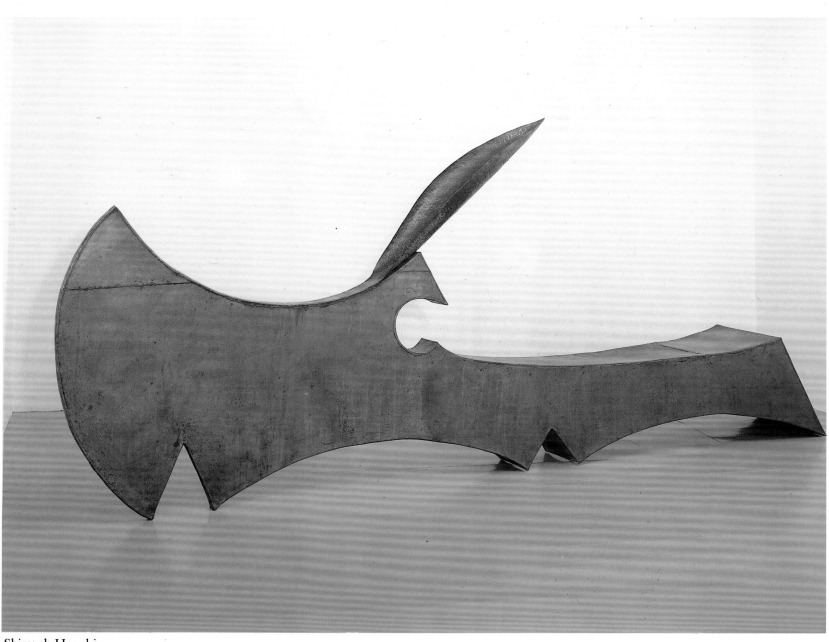

Shirazeh Houshiary
Ki 1984

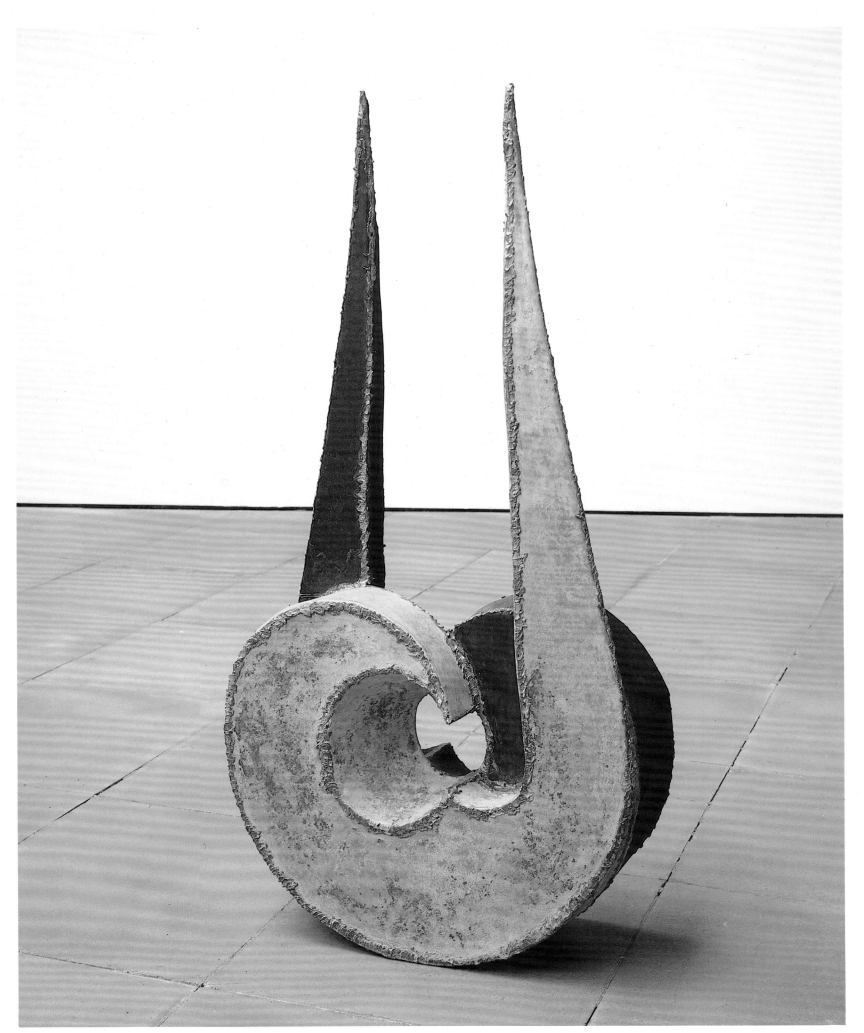

Shirazeh Houshiary
Fire 1987

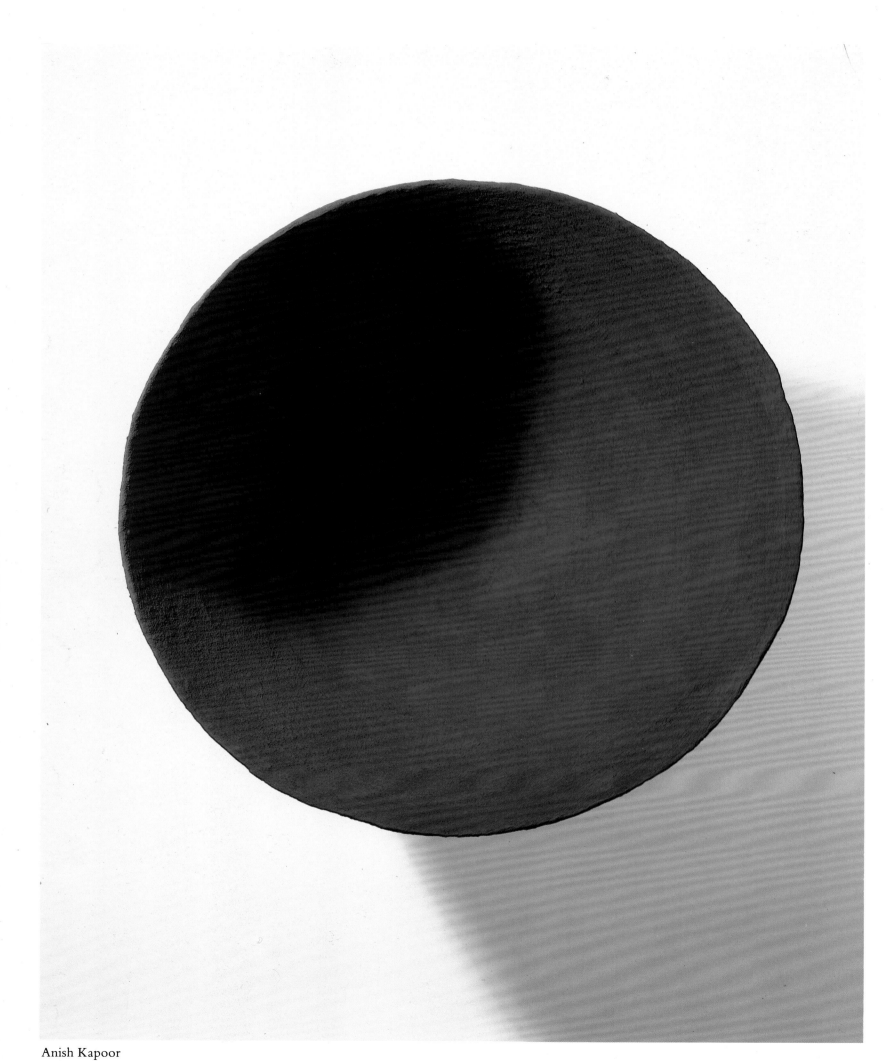

Anish Kapoor
22 *Void* 1987

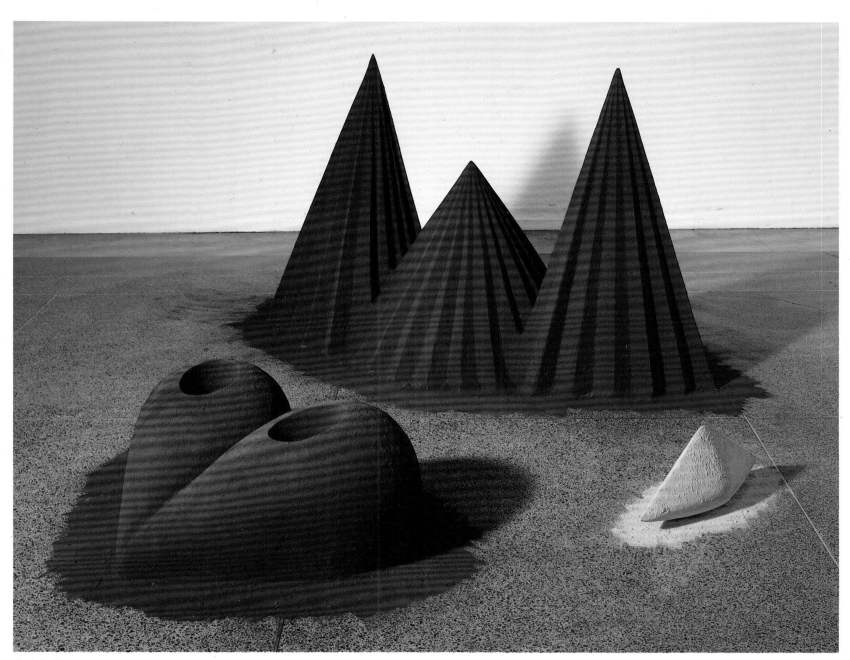

Anish Kapoor
*As if to celebrate, I discovered a mountain
blooming with red flowers* 1981

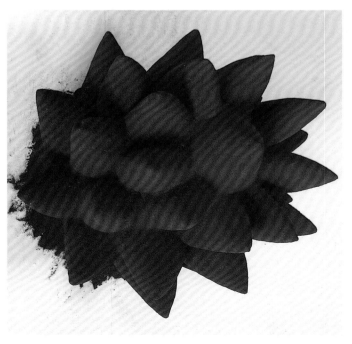

Anish Kapoor
1000 Names 1982

Next two pages:
works by Richard Long 23

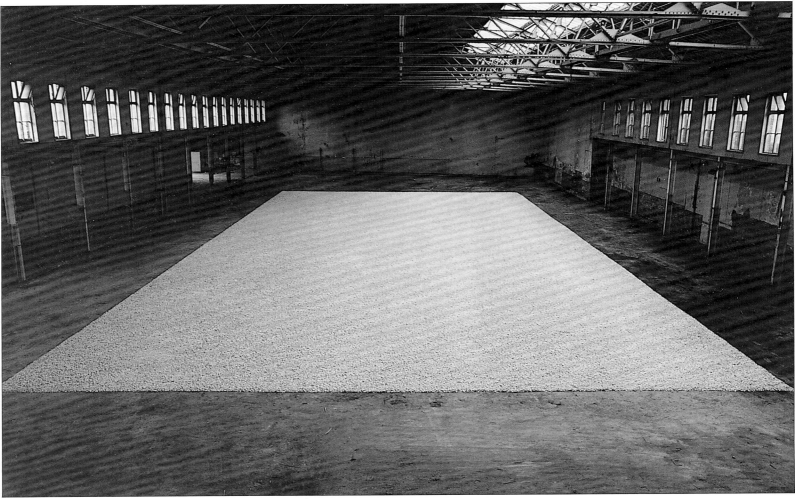

STONE FIELD
LIVERPOOL 1987

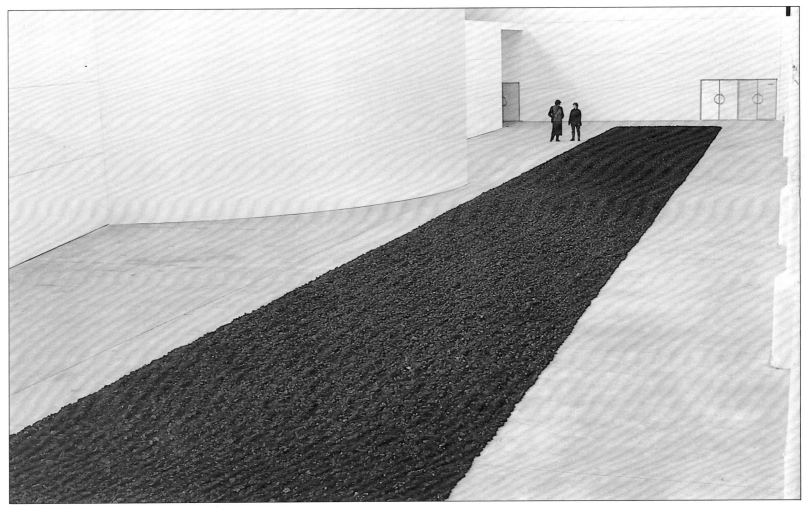

COAL LINE
GRENOBLE 1987

MUD WALK

A 184 MILE WALK FROM THE MOUTH OF THE RIVER AVON
TO A SOURCE OF THE RIVER MERSEY
CASTING A HANDFUL OF RIVER AVON TIDAL MUD
INTO EACH OF THE RIVERS THAMES SEVERN TRENT AND MERSEY
ALONG THE WAY

ENGLAND 1987

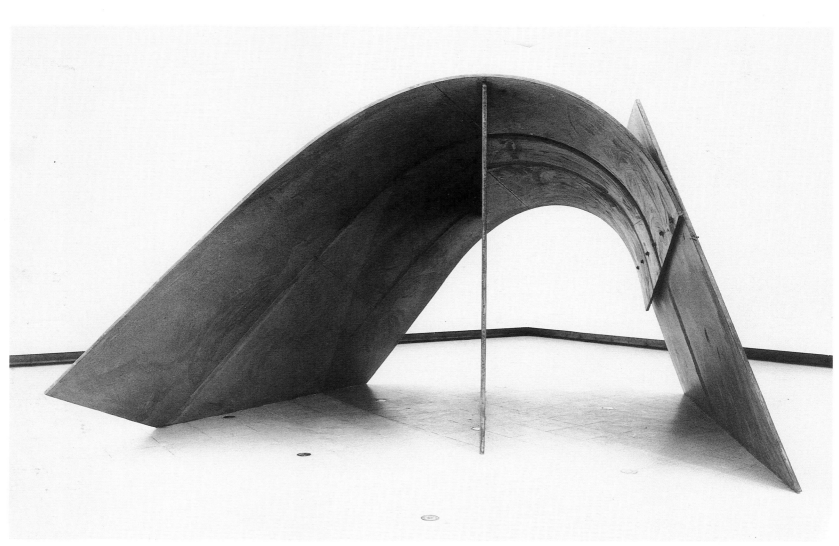

William Tucker
Tunnel 1972–5

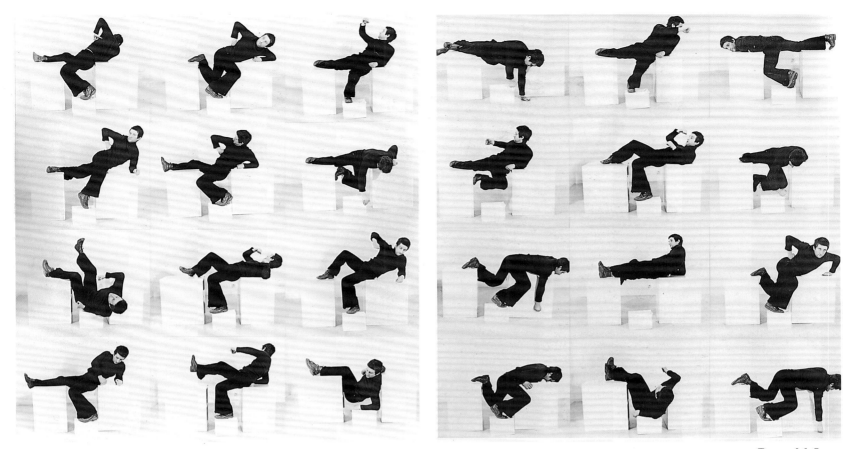

Bruce McLean
Pose Work for Plinths I 1971

Bruce McLean
Pose Work for Plinths II 1971

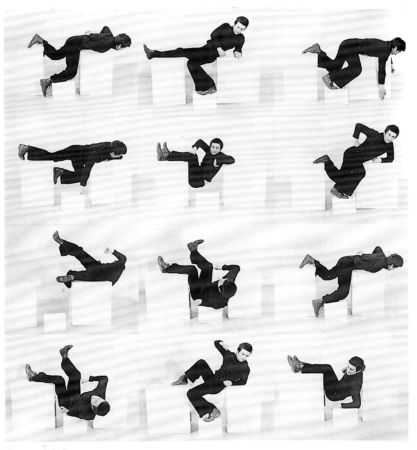

Bruce McLean
Pose Work for Plinths III 1971

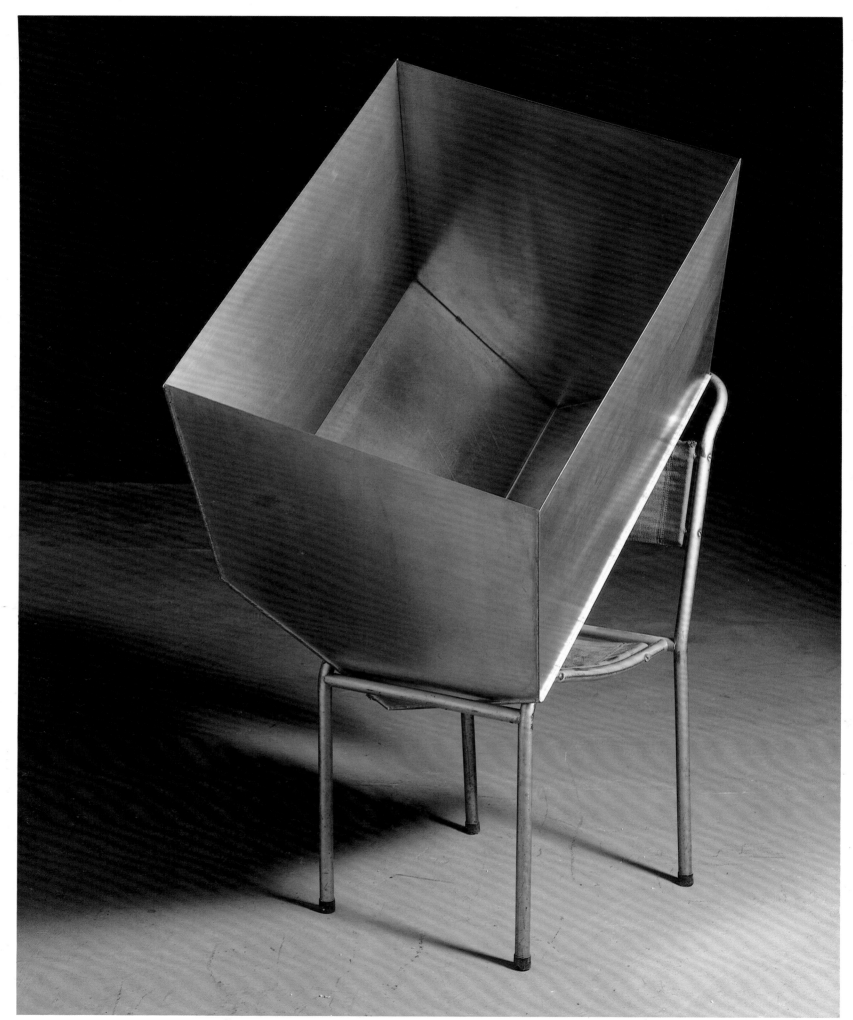

Richard Wentworth
28 *Cave* 1988

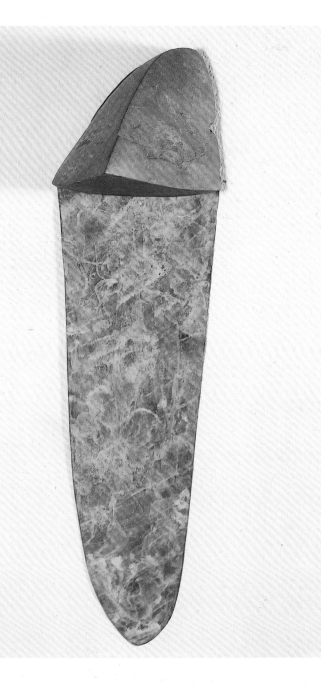

Alison Wilding
Green Beak 1983

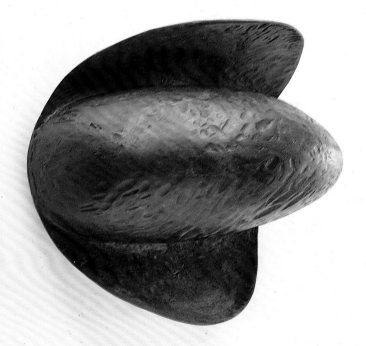

Alison Wilding
Still Waters 1987

29

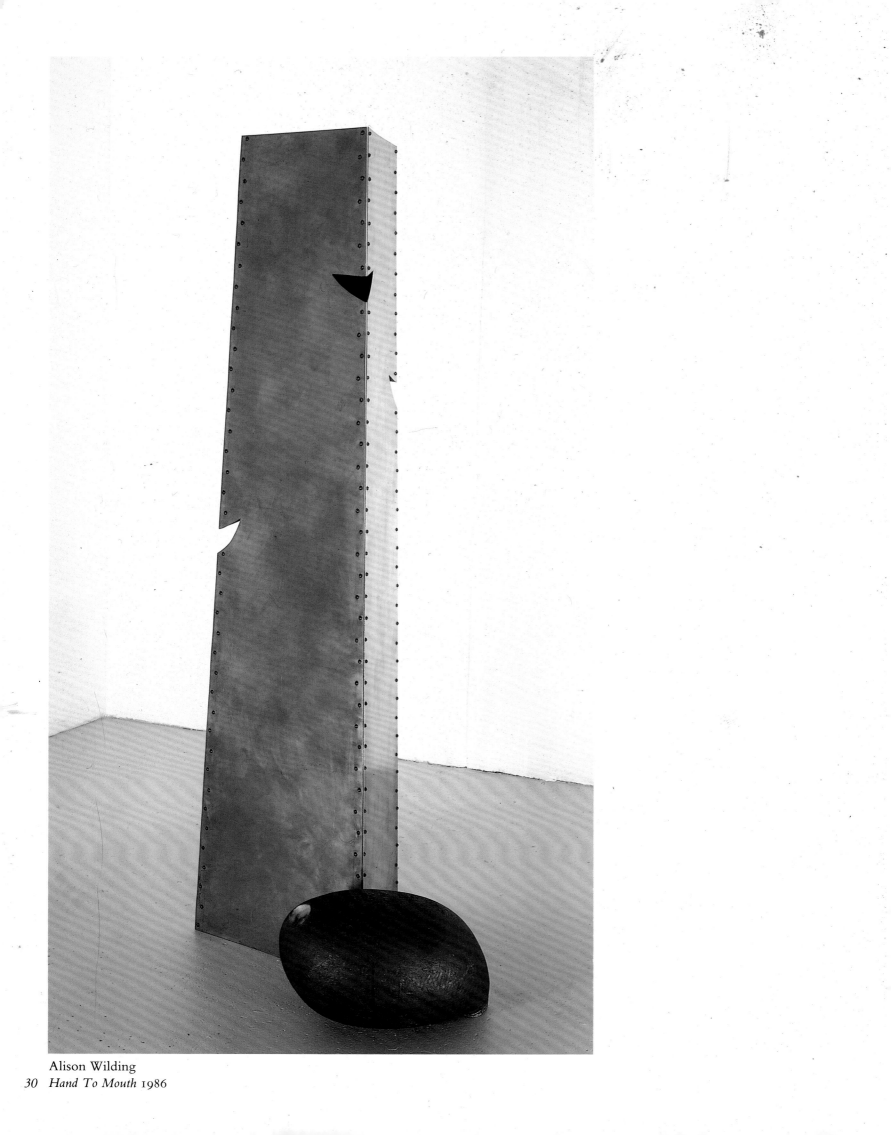

Alison Wilding
30 *Hand To Mouth* 1986

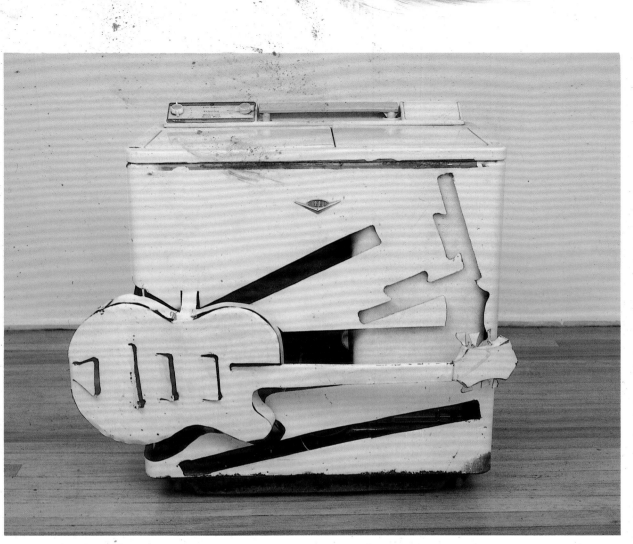

Bill Woodrow
Twin-Tub with Guitar 1981

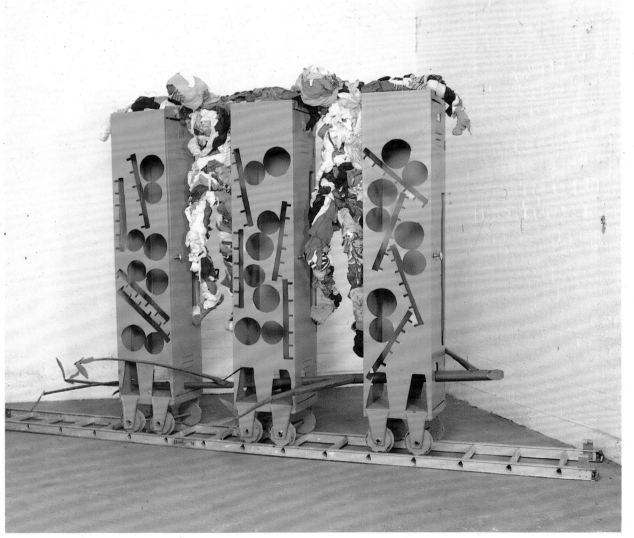

Bill Woodrow
Hobo 1988

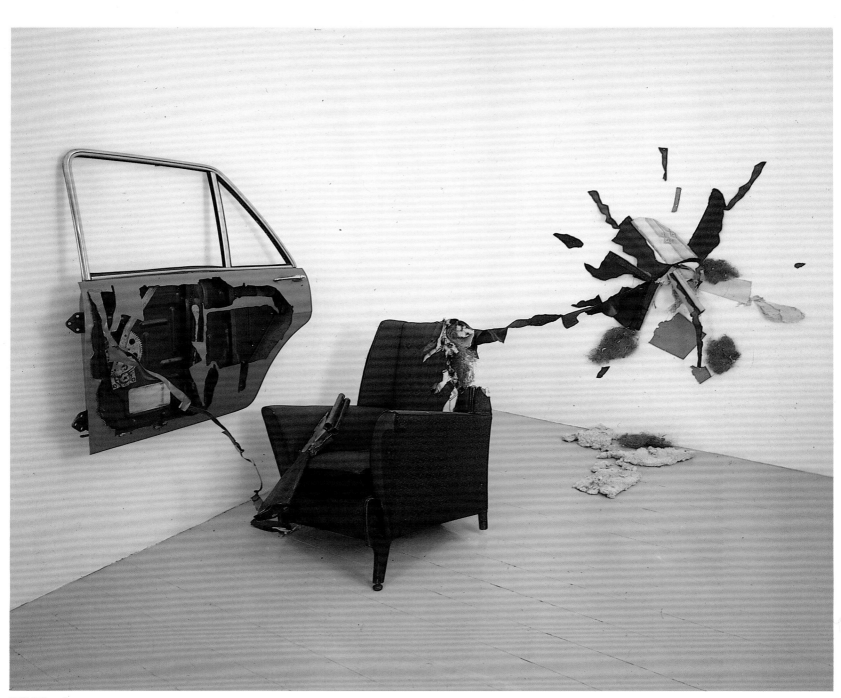

Bill Woodrow
Car Door, Armchair and Incident 1981

LIST OF WORKS IN THE EXHIBITION
Dimensions in centimetres
height×width×depth

1 Art and Language
Painting – Sculpture 1966
Acrylic on canvas mounted on plywood
Two panels, each 80×48
Courtesy Lisson Gallery, London

2 Art and Language
Air Conditioning 1966–67
Air Conditioning Unit
According to installation
Courtesy the artists and Andrews
Industrial Equipment

3 Art and Language
Map not to indicate 1967
Monochrome print relief
50.8×62.9
Trustees of the Tate Gallery

4 Art and Language
*Map of thirty-six square mile surface
area of Pacific Ocean West of Oahu* 1967
Monochrome print relief
59.7×50.5
Trustees of the Tate Gallery

5 Tony Cragg
Spectrum 1984
Plastic
30×200×350
Courtesy Galleria Tucci Russo, Torino

6 Tony Cragg
Raleigh 1986
Cast iron, stone
193.8×326.4×341.7
Trustees of the Tate Gallery

7 Tony Cragg
Città 1986
Hardboard, wood, paint
250×200×260
Saatchi Collection, London

8 Tony Cragg
Mollusc 1987
Cast steel
312.4×256.5×157.5
Fundacio Caixa de Pensions,
courtesy Marian Goodman Gallery

9 Tony Cragg
Untitled 1988
According to installation
Courtesy the artist

10 Michael Craig-Martin
An Oak Tree 1973
Mixed media
15×46×14
Courtesy Australian National Gallery,
Canberra

11 Michael Craig-Martin
Four Identical Boxes with Lids Reversed 1969
Painted wood
61×243×91.4
Trustees of the Tate Gallery

12 Michael Craig-Martin
The History of the World 1988
Plastic tape
According to installation
Trustees of the Tate Gallery

13 Richard Deacon
For Those Who Have Ears #1 1983
Laminated wood and galvanised steel
with rivets
213.4×365.7×152.4
Saatchi Collection, London

14 Richard Deacon
Art for Other People #6 1983
Leather and brass
31×31×61
Private collection, London

15 Richard Deacon
Art for Other People #9 1983
Galvanised steel with rivets
53×35×11
Saatchi Collection, London

16 Richard Deacon
Art for Other People #12 1984
Marble, leather
15×30×15
Private collection, London

17 Richard Deacon
Art for Other People #8 1985
Plastic pipe and brass
15×35×35
Private collection, London

18 Ian Hamilton Finlay
with Peter Grant
Starlit Waters 1967
Wood, various
31.1×240×13.3
Trustees of the Tate Gallery

19 Ian Hamilton Finlay
with Edward Wright
4 Sails 1967
Etched and painted plate glass
55.5×43×0.5
Victoria Miro, London

20 Ian Hamilton Finlay
with Nicholas Sloan
Osso 1987
Inscribed marble
20×90×182.8
Collection of the artist

21 Barry Flanagan
*Four Casb 2'67, Rope (Gr 2sp 60) 6'67,
ring 1'67* 1967
Canvas, various
According to installation
Trustees of the Tate Gallery

22 Barry Flanagan
Sixties' Dish 1970
Various
157.5×134.6×95.2
Trustees of the Tate Gallery

23 Barry Flanagan
Leaping Hare with Crescent and Bell 1983
Bronze edition of 7
121.9×94×61
The artist, courtesy Waddington Galleries

24 Hamish Fulton
White Clouds 1978
Photograph, Letraset on board
78×108×2
Massimo Valsecchi Milan Italy

25 Hamish Fulton
Water 1984
Photograph, Letraset on board
84×109×2
Massimo Valsecchi Milan Italy

26 Hamish Fulton
Rock Path 1984
Photograph, Letraset on board
84×131×2
Massimo Valsecchi Milan Italy

27 Hamish Fulton
Ringdom Sunrise 1984
Photograph, Letraset on board
84×107×2
Massimo Valsecchi Milan Italy

28 Antony Gormley
Bed 1980-81
Bread, wax
28×168×220
Collection of the artist

29 Antony Gormley
Hold 1986
Lead, plaster, fibreglass, air
93×61×38.5
Collection, Shearson Lehman Brothers
Courtesy Desmond Page London

30 John Hilliard
Across The Park 1972
Photograph on board
101.6×50.8
Trustees of the Tate Gallery

31 Shirazeh Houshiary
Ki 1984
Copper, wood
160×400×40
The Contemporary Art Society

32 Shirazeh Houshiary
Fire 1987
Copper
109×52×16
Mr and Mrs J C Lemaitre

33 Anish Kapoor
*As if to celebrate, I discovered a mountain
blooming with red flowers* 1981
Wood, various
96.5×309.9×304.8
Trustees of the Tate Gallery

34 Anish Kapoor
Void 1987
Mixed media and pigment
83.8×83.8×63.5
Collection of the artist

35 John Latham
Art and Culture 1966-69
Assemblage; book, labelled phials filled with
powders and liquids, letters, photostats, etc.,
in a leather case.
7.9×28.2×25.3
Collection, The Museum of Modern Art,
New York.
Blanchette Rockefeller Fund.

36 Richard Long
Turf Circle 1966
Monochrome print, photograph on paper
27×30.5
Trustees of the Tate Gallery

37 Richard Long
A Line Made By Walking 1967
Monochrome print, photograph on paper
37.5×32.4
Trustees of the Tate Gallery

38 Richard Long
England 1968
Monochrome print, photograph on paper
31.4×47.6
Trustees of the Tate Gallery

39 Richard Long
A Line in Bolivia 1981
Photograph on board
124.1×96.2 (1st version)
88.3×121 (2nd version)
Trustees of the Tate Gallery

40 Richard Long
Wessex Flint Line 1987
Flint
1130×160
Southampton Art Galleries

41 Richard Long
Mud Walk 1987
According to installation
Courtesy the artist

42 Bruce McLean
Six Sculptures 1967–8
Photograph on board
50.5×78.7
Trustees of the Tate Gallery

43 Bruce McLean
Pose Work for Plinths I 1971
12 photographs on board
74.6×68.6
Trustees of the Tate Gallery

44 Bruce McLean
Pose Work for Plinths II 1971
12 photographs on board
75×70
Private collection

45 Bruce McLean
Pose Work for Plinths III 1971
12 photographs on board
74.9×68.3
Trustees of the Tate Gallery

46 William Tucker
Tunnel 1972–5
Laminated hardboard and steel
215×384×327
The artist, courtesy Annely Juda Fine Art,
London

47 Richard Wentworth
Shower 1984
Wood, metal and various
89×110×88
Trustees of the Tate Gallery

48 Richard Wentworth
Common Ground 1986–87
Steel, canvas
140×65×109
Private collection

49 Alison Wilding
Green Beak 1983
Slate and patinated copper
58×16×14
Arts Council of Great Britain

50 Alison Wilding
Hand To Mouth 1986
Leaded steel, brass, beeswax and pigment
200×81×53
Karsten Schubert Ltd

51 Alison Wilding
Still Waters 1987
Oilpaint on limewood, lead
27×32.5×13
Karsten Schubert Ltd

52 Bill Woodrow
The Long Aspirator 1979
Vacuum cleaner and concrete
28×706×43
Private collection

53 Bill Woodrow
Twin-Tub with Guitar 1981
Twin-tub
88.9×76.2
Trustees of the Tate Gallery

54 Bill Woodrow
Car Door, Armchair and Incident 1981
Car door, armchair, enamel paint
120×300×300
Private collection

55 Bill Woodrow
Ship of Fools, Locked in Paradise 1987
Galvanized duct, steel barrel, washboard,
copper, enamel paint.
124.5×142.2×50.8
Private collection

56 Bill Woodrow
Hobo 1988
Metal lockers, aluminium ladder, rags, wire,
enamel paint.
233×396×175
Private collection

THE BRITISH AVANT-GARDE OF THE 60s AND 70s

WITNESSED ON LOCATION IN 1970 AND 1980
Martin Kunz

*My first visit around 1970 –
alternative, avant-garde art of the 1960s*

Between 1969 and 1972, I spent a great deal of time in London and elsewhere in Britain including one-and-a-half years at the Courtauld Institute as an 'occasional-research student'. At the time, I was actually more interested in contemporary art than in the subject matter of my studies, which I financed by writing about recent English art for Swiss journals. My first explorations of London art galleries and museums were a disappointment. Not a single gallery was showing artists like Richard Long, Hamish Fulton or Victor Burgin, who had recently been discovered in Switzerland and Germany. Art journals of the avant-garde, such as *Studio International*, were devoted to the latest news about Conceptual Art and Land Art. The then co-editor of *Studio International*, Charles Harrison, who was soon to join the Art & Language group as well, contributed significantly to the emergence of an independent British standpoint. The first solo shows of this period and tendency presented artists who were and still are best known abroad. There was a considerable gap between the presence of these artists in the galleries and current discourse on art. Galleries and institutions in London did show contemporary art, but their selection tended to lag behind the latest developments in art and coverage abroad. In 1969/1970, I discovered the interesting work of Barry Flanagan at the Rowan Gallery. It did not seem so revolutionary, however, especially after working with Joseph Beuys in 1969 when he was putting up his first show at the Museum of Art in Basel. The casual ease and artificiality with which the English incorporate shabby ('*povera*') materials was still foreign to me. While Flanagan had already had two shows at the Kunsthalle Bern, the work of Michael Craig-Martin, also at the Rowan Gallery, was entirely new to me, though similarly non-sensual and artificial.

Something entirely different now began to interest me. Had this new British art perhaps found a venue in the less established art scene, had it become active on the so-called 'fringe', somewhat like non-mainstream music, theatre and performance? Coverage of this scene (pop music, rock, hippy generation) in Switzerland was rather patchy and slow. We believed that the ideals of an 'underground' culture and lifestyle were still alive in the countries of their origin. When I went to Britain in 1969, I thought this fringe culture would be more visible, as shown by publications, festivals and street activities. I also expected the art scene to be particularly active in the area of unconventional pictorial forms that were out to 'dematerialise' the artwork (Process Art, Events Art, Performances, Concept Art and all the shadings in between). I also found publications with addresses of people involved in alternative art and commentaries on the latest activities.

The most useful publication of this kind was *Time Out*, still a small undertaking in those days, which listed all fringe activities from music, dance, film, theatre to political demonstrations, flea markets, and both lesbian and gay events. *Time Out* even covered the Establishment. Thus, in the art field, it first listed all the fringe events, followed by a selection of the most interesting events at established institutions and galleries. The time and energy invested in following up on all of these activities was rewarded by the discovery of interesting places and people, who drew my attention to still other events. The experience of exploring the latest developments first hand has since stood me in good stead, as

Richard Long
Snowball 1964

Richard Long
A Line of Sticks in Somerset 1967

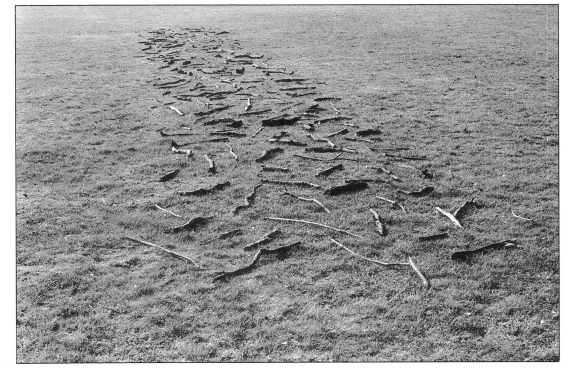

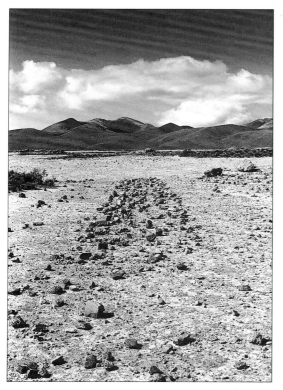

Richard Long
A Line in Bolivia 1981

professional pressures often prevent such thorough grass roots investigation. I have tried to avoid the pitfalls of second-hand information by taking several independent sources of information into consideration. The art scene, especially coverage and marketing, has changed so much since the 60s and 70s that comparable sources are no longer available. This was already apparent on my second encounter with new art in 1980. But let me return to what I 'bagged' the first time around.

My circle of contacts widened considerably through the artists I met at the Lisson Gallery, Nigel Greenwood Gallery and Sigi Krauss Gallery shortly after they opened in 1969/1970. People like Stuart Brisley, David Medalla, John Dugger, Paul Neagu, Marc Chaimowicz, Gustav Metzger, John Stezaker and many others were not only involved in Sigi Krauss's exhibitions and actions, but also met in the conspirative atmosphere of his basement workshop, where Krauss made beautiful picture frames for the Establishment while the conspirators planned the overthrow of conventional art. It was here that Brisley and Chaimowicz worked out their disturbing, repelling actions, shown, for instance, during the Performance Festival at the Royal Court Theatre, and that Medalla made the plans for his demonstration in front of the Tate Gallery. Art activism was just as important as innovation. But the greatest impact on me personally was made by John Stezaker's first public appearance, where I also bought one of his first works – a photographic piece on/of the gallery floor, very much in the spirit of Victor Burgin's 'Photopath' (1969). By keeping close track of Stezaker's development, I became acquainted with a precise analysis of Conceptual Art and saw the genesis of a critique of conceptual theory. While writing my thesis about the effect of the 'ready-made' on art history, I was stimulated and inspired by Stezaker, who was then working on a critical study of Duchamp and his reception. Knowing Stezaker's work and person so well gave me the impetus to mount an exhibition of his photo-collages at the Kunstmuseum Luzern in 1979.

Another strong impression of that period was seeing Gilbert & George as 'singing sculptures' in 1970 at Nigel Greenwood's first (studio) gallery in Chelsea. They literally embodied the notion of dematerialised and decommercialised art. What they were doing was, however, a far cry from any of the then popular, but rather crude and amateurish efforts of the alternative scene to equate 'life' and art. As impressed as I was by the determined attempt of anti-art-attitudes and manifestations to avoid any tangible product, their only lasting effect was often little more

than emptiness and boredom. But there were, of course, exciting people like Gustav Metzger, who kept hatching plans so radical that he could rarely execute them, or others who functioned as an *adjunct* to art, like John Latham and Stuart Brisley with their involvement in the APG (Artist Placement Group).

In Britain more art still bore traces of the Fluxus approach of the 60s than in the rest of Europe. I was fascinated by the consistency and artistic impact of its adherents, like Latham, mentioned above, whose early works were on view at the Lisson Gallery in 1970, and Mark Boyle, whom I met by chance at the ICA the same year, where he was watching the visitors at his own exhibition.

I was fascinated by their meticulously precise surface reality. In contrast to Spoerri's 'Trap Pictures', the line between recorded reality and the trick of recording it is blurred by flawless illusion. But I did not feel quite at ease with the theatrical presentation of Boyle's 'Earth Studies' on a floodlit black wall. Discussion with Boyle was inevitable, and we have yet to agree on such modes of presentation although his obsession with art is undeniably infectious. He does everything in his power to eliminate any personal presence in his pictures, to treat the beauty of things with radical equivalence, and to expand our sensual perception by means of synaesthetic experimentation. The works produced collaboratively with Joan Hills are imbued with a religiously motivated fascination and obsession, through which the artist's personal aura flows into the pure products of nature and life. The found object thus becomes a pure object of art. Through Boyle, I tried to grasp the history of the Fluxus and Happening movements, already on the decline in Britain. I followed him to the *London Now* Festival in Berlin where the performance of a *Requiem for an Unknown Citizen* and his *Light Shows* for the *Soft Machine* concerts were to be staged. Instead, endless scandals and lawsuits, resulting in Boyle's escape from Berlin and the pressures of commercial interests, shattered any hopes of seeing what would probably have been the last and most complex 'total performance' of the 60s. Boyle's trials and tribulations exemplified all the contradictions inherent in anti-art ideals, existential and productive needs, and the establishment pressures imposed upon successful non-mainstream art. These were the artists who were supposed to be exploring new modes of behaviour. Many of them sank into the mire of marginal living and ultimately disappeared along with the other 'underground' activities of the 60s. Boyle also faded into the background for a while, working in the remotest of venues. Bit by bit he has been getting closer to his plan (originally misinterpreted as a

John Latham
Art & Culture 1966–69

'concept') of defining 1000 sites on the surface of the earth. Moreover, he and his family are among the very few who have succeeded in integrating life and art. I mounted one of his first exhibitions in Luzern. In the meantime many of the artists I had met in Great Britain had acquired an international reputation: Gilbert & George, Hamish Fulton, Richard Long. Others, like David Tremlett, John Hilliard, Bruce McLean, Joel Fischer, Marc Chaimowicz, had enough energy to keep plugging along without notable successes, until the breakthrough came at the end of the 70s. Still others, like Ian Breakwell, Stephen Willats, Stuart Brisley, clung too rigidly to the concepts of the 60s in an effort to impose them on a radically different day and age. Naturally, I also saw many paintings and sculptures at the time, some of which were quite impressive like the work of John Walker, but I was primarily attracted by the exploration of a different, dematerialised art. In that respect I was myself a typical child of the age.

My experience of the eighties

The ten years since 1970 have brought about great changes in the fine arts and in my personal life as well. Instead of studying and working on the side as a freelance art critic, I now direct a museum. I no longer have the time or leisure to roam the world looking for young artists, but I do have the wish and the means to foster and show new art and young artists.

Since 1977 I have been able to carry out all the projects that I had been toying with for years: Boyle, Stezaker, Acconci, Snow, Aycock and others. On trips to Italy, Germany and Austria in 1978/79, I became acquainted with a whole new generation of art and artists, which was extremely irritating, disturbing, but very stimulating as well: installations of traditionally executed pictures, sensitive, representational drawings, expressive paintings – altogether a highly emotional, literary and mythological output with an outspoken emphasis on classical imagery and forms. In 1978 younger artists, critics and dealers sent me to the studios of artists like Clemente, Chia, Paladino and Tatafiore. I wanted to put them on view in 1979, but was not strong enough to swim against the tide of a market strategy that was by then already too ambitious to leave the museum première of the 'Transavantguardia' to a young (too young) curator.

The changes in art and my experience with the ideals of the 60s taught me to appreciate qualities that had been considered *passé* and that I had never been able to really enjoy before. My first direct contact with art had taken place at a time when *pictorial traditions* were categorically *taboo*. The blue pigment on a de Maria or the sensitively mannered representations of a Clemente or Paladino painting easily *seduced* me. Stezaker's dry photo-collages – cut out of Italian penny romances, rearranged, and sometimes rather sloppily glued – suddenly seemed musty and unsensual. I realised that the meaning of this kind of art cannot be conveyed without knowledge of its theoretical underpinnings. This is not a personal critique of specific artists like Stezaker, Willats, Art & Language or Burgin. It just seemed to me that developments in the 70s had invalidated many elements common to art at the turn of the decade. The renunciation of *avant-garde taboos* was therefore an irritating, but highly promising new perspective. Initially, little seemed to be happening in this direction in Britain. Some of my longtime artist friends clung bitterly to their premises in vehement opposition to such radical change.

While working on the exhibition, *Art of the 70s*, at the Venice Biennale in 1980, I had the opportunity to study Szeemann's *Aperto 80* survey exhibition of the latest trends.

Richard Long
Crossing Stones 1987

CROSSING STONES

A STONE FROM ALDEBURGH BEACH ON THE EAST COAST CARRIED TO ABERYSTWYTH BEACH ON THE WEST COAST
A STONE FROM ABERYSTWYTH BEACH ON THE WEST COAST CARRIED TO ALDEBURGH BEACH ON THE EAST COAST

A 626 MILE WALK IN 20 DAYS

ENGLAND WALES ENGLAND

1987

There I met Tony Cragg, one of the few artists to represent Britain besides McComb (and Bruce McLean in the 70s show). That same year I became acquainted with Stephen Cox (in addition to Lebrun and Cragg) in Modena at the exhibition *Enciclopedia: Il magico primario in Europa*. Cragg and Cox drew my attention to new art in Britain, especially sculpture. Although these two sculptors approach their *metier* from very different standpoints, they both relate to the tradition of English sculpture. In contrast to recent painting, which strictly ignores any association with art immediately preceding it, I saw in these two exponents of recent sculpture clear references to the preceding generation: in Cragg's case to Richard Long, in Cox's early work to Minimal Art. Cox's approach to stone sculpture and the illusionist technique of Renaissance reliefs embraced recent painting's reinstatement of tradition. Cragg was less concerned with traditional technique or forms; his work reflected these developments through the representation of very simple, mundane objects as well as the use of ordinary rubbish: bits and pieces of plastic sorted by colour and laid out to form a kind of loose mosaic. The screaming colours

of our age combine to make new statements both in Cragg's bits of plastic and in the expressive pictures by the *Neue Wilden*.

My encounter with Cragg and Cox in 1980 whetted my appetite. I wanted to know more about recent British art in general, especially in the field of sculpture. Although Cragg and Cox were able to tell me about British colleagues, they had both been away from their country for some time: Cragg was working in Wuppertal, Cox in Italian marble quarries. I decided to take a look for myself. Although I did not have as much time to make discoveries as in 1970, I had a clearer notion of what I was looking for and I was not burdened by the ideal of discovering the entire British art scene. I was particularly interested in new approaches to sculpture. Cox and Cragg had given me the names of about a dozen people. Incidentally, tips from artists whose work one knows and appreciates are by far the best means of discovering interesting, unknown talent. Exhibitions of new sculpture on view in 1981, i.e. *British Sculpture in the 20th Century* at the Whitechapel or *Objects and Sculpture* at the Arnolfini Gallery in Bristol and the ICA, facilitated my search for orientation. Armed with suggestions from other

John Hilliard
Across the Park 1972

well-informed people, I put together a tight schedule for my stay in Britain. Having been given expert advice and recommendations on which to base my selection, I did want to meet the artists personally as well. After visiting over 20 studios, I found half a dozen very exciting artists and decided to make an immediate, limited selection for a compact exhibition in Luzern. Things had been different back in 1970 when I was not forced to take a stand: writing about art does not necessarily entail passing judgement.

For the exhibition, *Englische Plastik heute – British Sculpture Now*, I finally narrowed the selection down to Stephen Cox, Tony Cragg, Richard Deacon, Anish Kapoor and Bill Woodrow. Making the selection was a decisive experience for me because I was in effect making a statement about our time, about a specific situation in the fine arts. On the other hand, the choice was not meant to be representative. Nor did the work display common external characteristics that would seem to identify and postulate a trend. The absence of Gormley, Vilmouth or Blacker, for instance, was more a question of personal taste rather than a value judgement. Some people, like Shirazeh Houshiary, fascinated

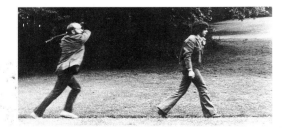

me but I felt that they were not yet ready for an exhibition. Then there were others whose work I had seen and liked but whom I had been unable to meet personally while in Britain – Alison Wilding, for instance, whose work I was not able to show until later. The importance of personal contact with artists is illustrated by Richard Deacon's work. When I visited him, he showed me photographs, fragments of disassembled objects, and the beginning stages of his series 'Art for Other People', but hardly any finished works. Having recognized the quality of his sculpture and ideas through drawings done in 1979, I had only to meet him personally to realise that I had discovered an extraordinary artist with a highly unconventional approach to form, substance and sensuality, even though there was no predicting what direction his work would take.

Like Richard Deacon, Anish Kapoor and Stephen Cox display a powerful sensuality and an erotic ambivalence that is diametrically opposed to British avant-garde art of the 70s. The intensely physical presence of Cragg's and Woodrow's sculptures is not imbued with the erotic ambivalence of their compeers but its candid immediacy and simplicity of means and imagery also set it off against the avant-garde of the 70s in England. My interest in British sculptors of the 80s may well have been triggered by their departure from the not unappealing, but convoluted scurrility of art in the 70s. They mirrored a similar transformation in my personal attitudes towards art, which is certainly one reason why I found them so appealing. I have since discovered unmistakable affinities not with the immediately preceding generation but, surprisingly enough, with post-war British art in the tradition of Henry Moore, Barbara Hepworth or Bacon and Freud. Their work was a blend of sublimity, preciousness and formal perfection with a highly ambivalent eroticism. The rapport with the younger generation seems to be less manifest because the latter do without figurative, imagistic representations. Cragg and Woodrow are different. For once their British humour is not based on a slightly inhibited, erotic scurrility but instead on the ambiguity of their subject matter. One can observe a cultural identity that comes as a surprise, especially since the new art of the 80s was initially interpreted as a generational reaction to the international history of the avant-garde. Thus, even before the close of the decade, cultural specifics have become apparent not only in German painting or the Italian *Transavantguardia*, but in British sculpture of the 80s as well.

Translation: Catherine Schelbert

THE SUPPRESSION OF THE BEHOLDER: SCULPTURE AND THE LATER SIXTIES

CHARLES HARRISON

I

Few people are likely to disagree with the statement that the 1960s saw a significant shift in the terms of reference for art. It would be harder, though, to secure agreement either about the reasons for that shift or about its consequences. Between 1968 and 1972 a host of international exhibitions variously represented the activities of a cosmopolitan avant garde which had seemed to form in the years 1965–1967 out of a number of local tendencies[1]. The impression of variety survives in memory and in catalogues and is confirmed by the plethora of labels preserved in the literature of the time. No other such brief period in the history of art can have witnessed so many attempts to name a movement or to distinguish its factions[2].

Faced with 'artworks' in the form of proposals and denials, accumulations and removals, interventions, journeys and category mistakes, the critic, the curator and the would-be art-historian sought for language with which to map the ground into which the new avant garde was supposed to have advanced. Before even the normal occupational problems of description and evaluation could be addressed however, it was necessary somehow to single out those aspects or phenomena which were the 'works of art' from the mechanisms of publication, distribution and display by which they were made manifest[3]. To attempt to do this was to operate within the range of some theory as to what could and what could not come up for the count as 'art'. In face of the traditional resources of theory, however, much of the work on offer appeared anomalous and evasive. In attempting to situate themselves physically and psychologically with respect to that which was presented to view, interested spectators found themselves without recourse to those kinds of convention which had previously served to demarcate between the contingent and the aesthetic – or to fix the meaning of each within a symbiotic relationship between the two.

This deprivation is in itself significant – and more significant than any claim for the avant-gardism of the works in question which simply remarks the relative informality of their appearance. It might seem with the benefit of hindsight that what united the various local tendencies of the late sixties – what made it feasible to see them converging into an inchoate international movement – was the apparent determination of those many and various artists involved somehow to circumvent the formal and morphological protocols of mainstream Modernist art (or to put it in the cruder terms espoused in some contemporary journalism, to pursue the idea of a 'Dematerialized' or 'Post-Object' Art[4]). There is no doubt some truth to this, but it is a weak formulation[5]. A better-supported hypothesis is that what had to be circumvented by the new avant garde was not Modernism itself, but rather that particular 'Abstractionist' *representation* of Modernism, and of the forms of experience by which Modernism was characterised, which was expressed in the dominant critical tradition of the post-war years.

Despite the recent fashion for tracing back the moment of inception of the 'Post-Modern', it could be said that what was at stake in the art of the later sixties was not the supersession of Modernism but rather its recovery as practice from the grip of an aesthetic discourse which had become manipulative and bureaucratic. The achievement of this recovery required that certain competences be unseated from the central position they had long occupied in normal accounts of aesthetic experience. In turn this requirement imposed certain forms of artistic practice upon the emergent avant garde. Though the very diversity of artistic forms published and exhibited during the years 1968–72 is in itself a matter of undoubted interest, and one which stands in need of explanation, the procedure of this essay will be to single out certain tendencies from among the rest and to consider these in terms of a restricted pattern of problems and concerns. It will be necessary to consider that representation of Modernism which was predicated on the abstract painting and sculpture of the early sixties in order to understand how and why it was opposed in the later part of the decade.

II

As implied above, the problems of description and identification which confronted the viewer of the new work of the later sixties were relatively alien to the typical viewer of mainstream Modernist art, at least as that art was represented in the mid sixties. We might even say that prevailing ideas about what the

Lawrence Weiner
A 36"×36" removal to the lathing or support wall of plaster or wallboard from a wall 1968

conditions of spectatorship properly included were such as necessarily to rule out any acknowledgement of such problems – just as 'the literary element' or 'content' or 'subject matter' had been ruled ultimately irrelevant to considerations of quality[6]. In return for submission to these injunctions a form of security was offered to the attuned viewer by the works of the colour-field painters and the abstract-and-constructive sculptors of the sixties. The descriptive vocabulary appeared to be given in their presence, and so, to a large extent, did the valuations. Or at least there was a learnable method available – a set of models of how one got from the description to the valuation. And that progress from description to valuation was made in a world in which certain things could be assumed to be true – a world in which the ontology of the work of art, the conditions and psychological models of spectatorship and the principles of valuation were held together and in unity in the sensitive and civilized mind.

One important assumption made in this world was that works of art are things made to be looked at – or 'beheld', to use a term given special currency by Michael Fried[7]. If that seems a truism, we should note that not all possibly canonical works of modern art are necessarily seen as fulfilling the description. The ready-mades of Duchamp, for instance, were used in the later 60s and have been used since as examples of a form of art which – whatever its merits or its inadequacies – was *not* addressed to the beholder. The argument that the ready-mades were never meant to be paintings or sculptures and are beside the point simply begs the question as to how and why the technical categories of painting and sculpture are privileged and restricted. We might also note that Duchamp's work informed (or distracted) Jasper Johns' painted work of the early sixties and that an *opposition* to the idea of works of art as things made exclusively or even primarily to be beheld was already prepared by that time. A further observation to be made is that the theoretical bond which connected abstract painting and sculpture under the dominant critical régime of the sixties was effective only in so far as, and for as long as, sculpture could be envisaged as an art which aimed 'to render substance entirely optical, and form . . . as an integral part of ambient space'; so long, that is to say, as it fulfilled the prescriptions for a paradigmatically Modernist pursuit of 'self-sufficiency' as a *visual* art which Clement Greenberg had set out in 1958[8].

In the mid sixties these prescriptions did indeed seem to be fulfilled in the work of Anthony Caro and of the closest of his followers, specifically those who were associated with the advanced sculpture course at St Martin's School of Art and who were identified with the 1965 'New Generation' exhibition. As early as 1949 Greenberg had pointed out the advantages to the sculptor of the 'virginality' of the constructive technique: 'All he need remember of the past is cubist painting, all he need avoid is naturalism'[9]. This may not have been quite true, but it was an apt forecast of the means by which English sculptors in the 1960s achieved amnesia with respect to a native tradition which had become an embarrassment. Furthermore, in the wake of American painting's triumphant progress across Europe, to claim Cubism as the significant antecedent practice – as Caro did – was effectively to narrow the conceptual gap between sculpture and painting at a moment when the prestige and vitality of the latter were unquestioned. The changes effected in British sculpture around 1960 are not to be adequately explained without recognition of the current status of American painting. The impetus for *modernisation* of the former came very largely from the latter. The gap between the two forms of art was still further narrowed by the adoption at St Martin's of an ideology of improvisation and 'open-endedness' under which it was possible to conceive the American sculpture of David Smith as compatible in practice with the American painting of Jackson Pollock, Kenneth Noland, Jules Olitski and others.

Certain situational questions followed upon the assumption that works of art were things to be beheld. How was a beholder qualified as such, or what form of public did the canonical Modernist art of the early sixties require or presuppose? Under what conditions did

New Generation, 1965, Whitechapel Gallery, installation view

Anthony Caro
Early One Morning 1962

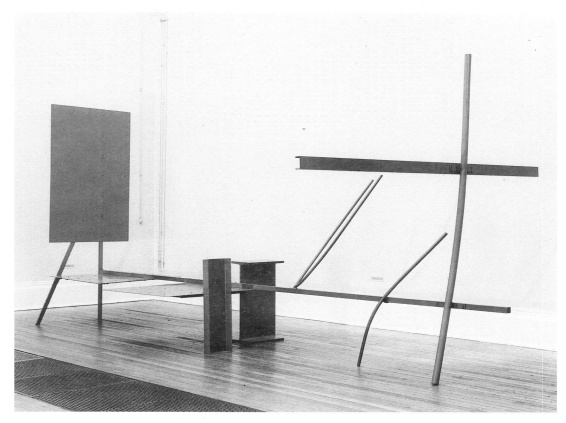

Art and Language
Documenta Index 1972

Donald Judd
Untitled 1987

beholding take place, or what forms of exhibition and distribution were required or appropriate? To what end did beholding lead, or what form of social or other function did this art fulfil? In considering how these questions might be answered with respect to the abstract painting and sculpture of the sixties we begin to get a sense of the very special kind of relationship which is here signified by 'beholding'. It was not simply to be achieved by anyone under any conditions, nor was it mere looking or regarding or being-aware-of that was being proposed. Under its prevailing critical representation, this art – like the annunciating angel in a quattrocento painting – made itself visible in its intensional aspect only to those who were properly receptive and attuned and only in certain kinds of sanctified space. And if we asked to what the experience of beholding was supposed to lead, the boldest answer was that it led to nothing. It was an experience in and for itself.

Works of art formed under these assumptions were bound to be marked by their implications. The intention to facilitate the special and concentrated experience of beholding led to the conceiving of 'sculpture' as realised in things which were syntactically compact but not formally monolithic, which stimulated the discrimination of formal relations within a hermetic system, rather than provoking a search for figurative or metaphorical connections to the world at large, and as things suitably perceived in some context removed from the contingencies of the social, rather than confronted under conditions which established some sense of dialogue with those contingencies. My object is not – as it might seem – to ridicule the abstract painting and sculpture of the sixties. Rather it is to account for its attractiveness and its plausibility; to suggest how very deeply embedded were its cultural and theoretical foundations in

the history and language of sensibility, enlightenment and mastery, how compact it was with a discourse of spiritual and transcendental values, and thus how powerfully secure was the cultural edifice which an oppositional avant garde would have to confront.

III

As regards the practical and theoretical possibilities of *artistic* opposition, much of the ground had been prepared by the American Minimal artists during the mid sixties. In 1965 Donald Judd quixotically pronounced sculpture 'finished' and proposed in its place a range of 'three-dimensional' work'[10]. If the methodological example of his own criticism was a reliable guide, the intention of his own 'specific objects' was that nothing relevant should be sayable about them which was not a description of their physical characteristics and means of fabrication. They stood as forms of mute critique of those exciting metaphysical pretensions which characterised art-critical and art-historical interpretation in the wake of Abstract Expressionism. A year later Robert Morris asserted the hostility of the concerns of sculpture to those of painting[11] and subsequently pronounced the virtual demise of the latter, consigning it to the realms of the antique on the grounds of 'the divisiveness of experience which marks on a flat surface elicit'[12]. In his own 'three-dimensional work' Morris was preoccupied with the relations between perceiving and conceiving, with the persistence in the mind of certain 'gestalts' and with the recovery of fabricating processes in the encounter with forms and materials.

Abstractionist theory had laid stress upon 'newness' in the experience of art. Minimal Art dealt with standard forms and, at least in that tendency within Minimalism with which Morris was associated, with the situational and even sociological contexts of art. It reintroduced that engagement of high art with other forms of manufacture which had been a feature of earlier phases of artistic Modernism but which had been largely excised from retrospective view since the war. And it demonstrated a practical alertness to the moral and cognitive character of production – a character which is only contingently and circumstantially manifest in the *appearance* of things. So far as concerned the envisaged spectator of these enterprises, no evident facility was provided for that kind of detached self-sufficiency in experience by which the beholder is characterised – a deficiency which led Michael Fried to dismiss Minimal art as 'theater' and to condemn Minimal artists for their 'literalism' (a term which took its meaning precisely by contrast with the value he attached to 'abstraction'). The publication

of Fried's article 'Art & Objecthood' marked a kind of watershed[13]. Certainly, it served to alert English readers of *Artforum* to the strength of a defensive reaction – and thus, perhaps, to the possible critical implications and extensions of Minimal art vis-à-vis the more orthodox art of American abstract painting and of its transatlantic partner, British abstract sculpture.

For all the apparent extravagance or dramatic meagreness of its physical components, the great majority of the new informal, 'anti-formal' art of the later sixties, where it was not simply an extension of art-student craftiness and individualism was made in pursuit of the exploitable implications of Minimalism. The canonical abstract sculpture of the mid sixties furnished a set of negatives and contrasts: the new work was not stable, not hermetic, not generally reliant upon significant and constant relations of difference between parts, not necessarily insulated against aesthetic collapse by the empty white-walled gallery, nor necessarily rendered vulnerable by dislocation from it. It was not sustained in its 'visuality' by the illusion of weightlessness. Rather its materials and its forming processes were thermatised in relatively 'literal' form.

IV

The drama of such oppositions rarely survives the passage of decades, however, unless substantial shifts in the constituency of art are achieved in the process. It may be that the Minimalists' notion of 'three-dimensional work' sketched out a form of potential which was unrealised to the extent that subsequent work claimed for itself and was accorded the privilege of 'sculpture'. Certainly the lure of that privilege played a large part in the development of British art during the seventies[14]. For all the talk of change and liberation which accompanied the anti-formal movement of the later sixties, new forms of 'three-dimensional work' for the most part adjusted themselves under the beholder's eye to take their place in the tradition of 'sculpture' – a tradition which the current exhibition joins in celebrating.

It is to the Conceptual Art of the later sixties and early seventies that we have to look to recover some sense of a *threat* to tradition. It should be acknowledged that the greater part of what passed for Conceptual Art amounted to little more than the conceiving of new forms and venues for the 'ready-made'. It was from within the more assiduous aspects of the movement, however, and specifically from within the practice of Art & Language, that the assault upon the beholder was most explicitly mounted. The project was to render him incompetent, to introduce strategic anomalies into the museum of his mind, to threaten his self-sufficiency with practicalities and contingencies, and to stretch his powers of definition and description with philosophical paradoxes and theoretical fictions. (The use of the masculine pronoun here is not merely conventional. The paradigm beholder was male.) The pursuit of this project required abstinence from all those forms of delight and complexity in representation over which the beholder's competence was wont to extend. To this end it was also necessary that those distinctive competences which were associated with the making of painting and sculpture be deprived, at least in thought, of their status as determinants upon the concept of high art. Instead, practice was made of the representing and misrepresenting discourse itself, and of its own fissures and discontinuities.

Of course it was said that such work was not visual and (and thus) not art. It was also said by some that it was actively hostile to 'art'. And of course these were valid criticisms on their own terms. But the assumption that they were *sufficient* criticisms betrayed an inability to conceive the conceptual conditions of failure or defeat of the prevailing Abstractionist account of Modernism and of the aesthetic. This in turn entailed an inability or unwillingness to comprehend the intentional aspect of Conceptual Art, for the 'artistic' representation of those very conditions of failure and defeat was the *effect* for which it was striving. Therein lay its claim to a form of realism. Further, it was implicit in the works of the Conceptual artists that this inability was symptomatic – if it was not at some level a contributory cause – of the loss of critical power in Modernist culture; of the bureaucratisation of the imagination in the name of the sensitive; of the restriction of the cognitive in the name of the visual; of the suppression of the critical in the name of the creative; and of the marginalisation of the participant in the name of the beholder. In the later sixties and early seventies, the task of recovery of modernism in practice and in history, where that task was better than arbitrarily addressed, was associated with restoration of the notion of art as a form of critical work.

V

Times change. If the moment of the later sixties was a form of failed revolution there can be no doubt about the success of the counter-revolutionary culture which surrounds us now. Its progress has not restored the beholder to his previous position of primacy, however. He was, after all, a figure in whose expensive conscience the traditional virtues of liberalism were enshrined. In the current culture of hysteria and replication the

Art and Language
Painting – Sculpture 1966

ideal spectator presupposed is one untainted by such soggy attributes. It may already be time, in fact, for the beholder to be reanimated, to be set loose again as the imaginary representative of value in our experience of art, as one whose faculties and interests might be mobilised under our present circumstances to relatively emancipatory and critically effective ends. What we need, though, is not a gentlemanly but a mad beholder – a beholder run amok[15]. At the end of the wide swathe which such a one might cut between the tedious zealots of art for the people and the repulsive puppets of business art, art of some critical depth and power awaits the paranoid eye.

NOTES

1. Among exhibitions which marked the emergence of contributing factions were: 'Eccentric Abstraction' at the Fischbach Gallery, New York, in the autumn of 1966; 'Hardware Show' at the Architectural Association, London, in February 1967; 'Arte Povera' at Galleria la Bertesca, Genoa, in September 1967; and '19:45–21:55' held on private premises in Frankfurt in the same month. The Dwan Gallery, New York, staged the first of its 'Language' shows in 1967, and 'Earthworks' in 1968. The first major international surveys were 'Op Losse Schroeven' at the Stedelijk Museum, Amsterdam, and 'When Attitudes become Form' at the Kunsthalle, Bern, both opening in March 1968, the latter travelling in somewhat changed form to the ICA, London, in September. The period of excitement – if not the duration of artistic careers – effectively closed with the 1972 'Documenta', at which the avant garde was provided with a vast international Salon.

2. A brief trawl of English-language publications yields the following: Post-Object Art, Multiformal Art, Non-Rigid Art, Concept Art, Conceptual Art, Idea Art, Ideational Art, Art as Idea, Earthworks, Earth Art, Land Art, Organic-Matter Art, Process Art, Procedural Art, Anti-Form, Systems Art, Micro-Emotive Art, Possible Art, Impossible Art, Arte Povera, Post-Studio Art, Meta Art.

3. This was not so much a novel problem in the history of art as one which had been suppressed by the art-critical protocols of the Cold War. Under this régime the destabilising practices of the Dadaists, the Constructivists and the Surrealists were allowed to feature as art-historical curiosities, but not as the moments of generation of an agenda of problems and practical strategies.

4. 'The Dematerialization of Art' was discussed by John Chandler and Lucy Lippard in Art International, February 1968. 'Post-Object Art' was a neoterism promoted if not coined by Donald Karshan in an essay written but not used to introduce the exhibition 'Conceptual Art and Conceptual Aspects' at the New York Cultural Center, April 1970, and published in Studio International, September 1970.

5. If such a view seems more plausible – more easily achieved – now than it did at the time, this may be because the 'exposure' of Modernism as a representation of culture, which had hardly commenced in the later sixties, has now progressed to become the stock-in-trade of the methodologically adequate critic or art historian.

6. See, for instance, Clement Greenberg's 'Complaints of an Art Critic', Artforum, October 1967, reprinted in C. Harrison and F. Orton eds., Modernism, Criticism, Realism, London and New York 1984.

7. See M. Fried, Absorption and Theatricality; Painting and Beholder in the Age of Diderot, Berkeley, Los Angeles and London, 1980. This study pursues into art history that distinction 'between "presentness" and "presence", instantaneousness and duration, abstraction and objecthood' which Fried theorised in his 1967 essay 'Art and Objecthood', first published in an Artforum special issue on sculpture in Summer 1967. For Fried's own retrospect on the issues raised see his contribution to the symposium '1967/1987: Genealogies of Art and Theory' in H. Foster ed., Discussions in Contemporary Culture, No. 1., SEATTLE, 1987. For a succinct account of the derivation of the Friedian viewer from the eighteenth-century man of 'vision', see Thomas Crow, 'These Collectors, They Talk About Baudrillard Now', contribution to a symposium on 'The Birth and Death of the Viewer', published in the same volume.

8. The quotation used is from the revised text of 'The New Sculpture', dated 1958 and printed in C. Greenberg, Art and Culture: Critical Essays, Boston, 1961. The original version of the essay was published in Partisan Review, June 1949. In the later version Greenberg strengthened his concept of the 'new sculpture' as an art of optical effects. The date of this revision is of some significance in consideration of the theoretical – and practical – bond forged between American abstract painting and British abstract sculpture during the 1960s.

9. Greenberg, 'The New Sculpture', loc.cit. 1949. The sentence is absent from the later version.

10. D. Judd, 'Specific Objects', in Arts Yearbook 8; Contemporary Sculpture, New York, 1965. Judd claimed that, 'Half or more of the best new work in the last few years has been neither painting nor sculpture'.

11. R. Morris, 'Notes on Sculpture', in Artforum, February 1966.

12. R. Morris, 'Notes on Sculpture, Part 2', in Artforum, October 1966.

13. See, for example, the symposium '1967/1987' cited in note 7.

14. In a much-quoted letter to Caro, written in 1963 and published in a student magazine two years later, Barry Flanagan wrote, 'I might claim to be a sculptor and do everything else but sculpture. This is my dilemma'. In fact, the designation of various forms of avant-garde activity as 'sculpture' has been particularly persistent amongst those who passed through St Martin's in the sixties, among them Flanagan himself, Richard Long and George Pasmore and Gilbert Prousch. In face of the institutional commitment and relative orthodoxy of Caro and the New Generation, some students in the later sixties pretended a fascination with the category 'sculpture' as if in a spirit of self-protective irony and insouciance. Subsequently, as artists with careers, they would have recourse to the category as a means of insulation of conceptually fragile work.

15. For a recent and extended intellectual performance by a quintessentially gentlemanly beholder, see Richard Wollheim, Painting as an Art, London and Princeton, 1987. For a commentary pertinent to the substance of this essay see Art & Language, 'Informed Spectators', in Artscribe, March/April 1988.

RE-DEFINITION: THE 'NEW BRITISH SCULPTURE' OF THE EIGHTIES

Lynne Cooke

Cragg: '. . .*making sculptures is for me a process that's always defining and redefining itself.* . .'[1]
As its bland sobriquet suggests, the 'New British Sculpture' is anything but a clearly defined, precisely identifiable art. To the extent that it can be coherently grouped, this sculpture requires other terms to account for its identity than those which normally apply: a unified style, a shared iconography or an aesthetic held in common. What Tony Cragg, Richard Deacon, Antony Gormley, Shirazeh Houshiary, Anish Kapoor, Richard Wentworth, Alison Wilding and Bill Woodrow share is certain more general responses to a particular context.[2]

All first showed their mature work around 1980–1981[3]. It was shortly after this that they were packaged together to constitute a group which could provide both an answer to the previous 'generations' who had dominated British sculpture since the war, and a much-needed counterpart to those young nationals, such as the Italian Transavanguardia, and the German Neue Wilden, then emerging aboard.[4] But not only is the notion of a succession of generations in post-war British sculpture a problematic one, what is held in common is insufficient to distinguish these artists from certain others of a similar age concurrently making three-dimensional work elsewhere, such as the German Harald Klingelhöller.[5] Furthermore, the 'New British Sculptors' share little with those figurative expressionistic painters who were concurrently gaining international art world attention. Their roots, by contrast, lie not in painting or conceptual art but in debates that centred on the extended forms of sculpture which developed during the later sixties, including land art, process art, and installations. Nonetheless, what is shared goes beyond a certain aesthetic tradition, or legacy. More significant than the fact that these artists belong to the same generation, loosely speaking, (all were born between 1948 and 1955) is their attendance at one or more major art college in London during the seventies.[6] Equally important is the fact that after experimenting with various types of performance, installation and/or conceptually based work, by the end of the decade all had gradually begun to concentrate on self-sufficient, relatively contained, fixed objects: objects which, moreover, were made by hand, and were fabricated rather than crafted from mundane, familiar materials.

If their work is to be discussed together–and, as indicated above, it is doubtful whether they can be seen as a distinctive group–then it must be in terms of a set of responses to their particular formative conditions and to certain prevailing issues.

The contribution of art schools to the development of art in Britain is a much debated topic. What has been felt to distinguish the English system is the way in which, in the better colleges at least, the majority of the staff have been part-time teachers who are also professional artists with a stake in ongoing debates. In addition, the practice of inviting visiting artists, often from abroad, to deliver occasional lectures serves further to keep students abreast of current concerns. These students had ready access to their immediate predecessors, Richard Long, Gilbert and George, Barry Flanagan and Bruce McLean, among others, not just through exhibitions but as a consequence of that tightly knit structure of art school and art world which distinguished the British situation.[7] That these slightly older figures had rapidly become an integral part of an interna-

Bill Woodrow
Ship of Fools, Locked in Paradise 1987

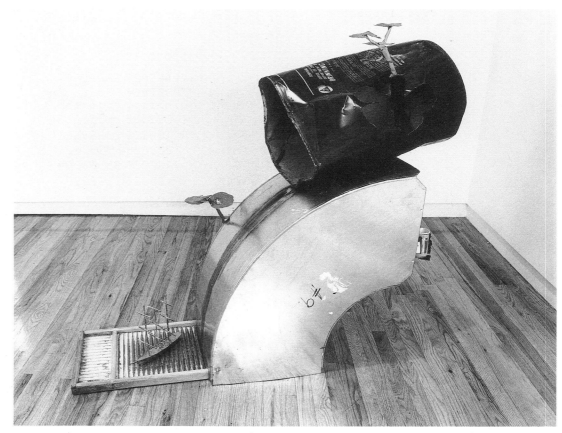

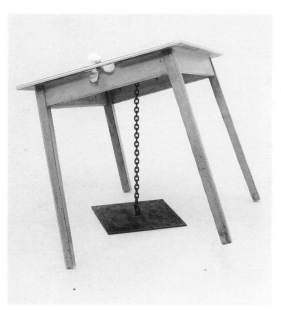

Richard Wentworth
Shower 1984

tional movement was also crucial: it set a level of ambition and professionalism to which Woodrow et al. might aspire. And while the courses on which they registered did not require the making of certain types of object or the display of certain acquired skills, object making in some form was stressed: all produced objects, or at least extended objects in the guise of installations, for their degree shows.[8]

If the debate as to what sculpture might be had first started in England within the walls of St Martin's School of Art, where Long, Flanagan, Gilbert and George, McLean, John Hilliard, Tim Head and others were all students in the late sixties,[9] during the seventies it was examined through the public fora of exhibitions and art magazines.[10] Two large-scale shows held at Hayward Gallery in the first half of that decade are symptomatic of the divisions in attitude that then prevailed.

Selected by the young curator Anne Seymour, *The New Art*, in 1972, brought together some twelve participants ranging from Gilbert and George, Flanagan, Long and Michael Craig-Martin to Art and Language, David Dye and Keith Arnatt, most of whom had trained in sculpture departments but no longer necessarily considered themselves to be sculptors as such. (McLean had by then stopped thinking of himself as even an artist and so refused to be included.) In her catalogue introduction Seymour noted that although a wide array of non-traditional materials and media were employed by these artists ultimately the media were less important than the ideas which governed the works. And while affirming that these artists were part of a larger international phenomenon, Seymour distinguished between two basic approaches: that for which other disciplines – such as philosophy, anthropology, cybernetics – provided the basic tools to examine the world at large, and that for which such non-material means were largely irrelevant, and which worked instead with materials 'to hand'. Together, they broadened the range of reference – the content – as well as the forms of sculpture. In contrast to the increasingly narrow and rigidly defined stance held by those formalist sculptors grouped around Anthony Caro at St Martin's School of Art (whose vision of sculpture was faithful to the theories of the American critic Clement Greenberg) these artists attempted a more rigorous materialist examination of the ontology of the artwork.

It was the formalist aesthetic which, however, underpinned the large international show held at the Hayward some three years later entitled *The Condition of Sculpture*. Its curator, the British sculptor and critic William Tucker defined sculpture as a self-sufficient, three-dimensional, fixed entity, subject to gravity and revealed by light; it constituted a discrete category of objects whose content was determined primarily by notions of rightness of form. In the event, this aesthetic was narrowly applied, for what was exhibited was mostly work that was abstract, handmade and hermetic.[11]

These two shows can be said to map either end of the spectrum of options available at that time to younger sculptors. The remainder of the decade witnessed a further fragmentation, with both an undermining of the pertinence of such categories altogether, and an exposure of the dubiousness of the claims made for many of the more extreme positions. In different ways and at different moments during the later seventies, Cragg, Woodrow, Deacon, Wilding, Woodrow and Wentworth all found themselves at an impasse; some even stopped working for a short period.[12] Though it would not necessarily have been phrased in these terms by any of the others, the issue which then preoccupied Cragg gradually became for each of them the central one: "For me, in the mid-seventies, the crucial question became one of finding a content, and from that came the idea that that might evolve through a more formal approach to the work".[13] What was at stake was the problem of devising a work which went beyond the temporary– gesture,[14] installation, or performance–and yet was neither formalist nor wholly subservient to conceptual concerns.

Theory of the type employed by Hilliard, Victor Burgin and others held no attractions to these younger artists since all had been trained in sculpture departments which had a strong commitment to manipulating physical matter, to a process-based activity, and to the use of mundane, everyday materials sited in relation to actual space. Consequently, for all of them, meaning had to grow out of and be embedded in the physical form itself: form could not be simply a vehicle for the expression of ideas. But meaning could not reside in form or in process alone,[15] it also derived from a certain approach to iconography, one that must circumvent both self-reflexive formalism and pure conceptualism. It was this conviction that now began to separate these sculptors from their immediate predecessors. Whereas the generation that matured in the late sixties had felt itself to be in strong rebellion against its forbears, Cragg, Woodrow and Deacon et al. saw the possibilities inherent in the aesthetics of both preceding groups as equally available, if not equally pertinent.[16]

Yet towards the end of the decade the relevance of each group was increasingly questioned by these younger artists. Thus,

together with those who, albeit variously, shared his preoccupation with a landscape based art, Richard Long's aesthetic appeared at odds with the urban world inhabited by most practitioners and their audiences. Moreover, his gallery pieces in stone or mud lent themselves, paradoxically, to apprehension in fairly straightforward formalist terms. And where Flanagan had formerly employed whimsy, risking an arch inconsequentiality in order to play quixotically on the margins of art, once he attempted to do this through the medium of more conventional modes and materials, like stonecarving and bronze, he rapidly blunted the critical edge of his art.

By contrast, at this moment, both Gilbert and George and Bruce McLean decisively shifted their focus away from a solipsistic and/or artworld preoccupation to address art's function as a consumer commodity, and as a bearer of cultural values in the social space. Around 1977 the 'Living Sculptures' traded their stance of self-preoccupied boredom, and depressed or drunken anomie, for a subject matter that alluded to the 'state of the nation', a nation then widely considered to be in a condition of economic decline, moral decay and social disruption: race riots, and the explosion of Punk (then regarded largely as a working class ethos), had unforgettably marked the summer of 1976. If Gilbert and George's position on issues relating to nationalism, patriotism, racism and sexism soon proved to be highly ambiguous, only gradually did it become evident that it was not the new subject matter which counted as much as the style that they promoted.[17] Increasingly scaled up into a monumental format, their photographic works in bold flat colour and sharp graphic design borrowed their idiom from the realm of magazines and advertising, and were in turn quickly reassimilated by the mass-media: this was precisely the point. Their credo of 'art for all' was calculatedly in tune with the marketing of a stylish product at the dual levels of consumer imagery and high art object. Moving beyond the position that art was about signs and sign systems, they acted as if artistic and commodity status had become the same thing.

Following the demise in 1976 of Nice Style, the World's First Pose Band, his vehicle for lampooning the foibles of the art world, McLean devised a series of 'choreographic' drawings–purportedly notions for performance pieces–on 'discarded' photographic paper. Seemingly throw-away, these works were in many respects tailor-made to the newly emerging aesthetic of street culture.[18] From there he rapidly branched into other forms, ranging from painting and sculpture, to 'designer' ceramics, wall-paper, furniture and the like. Common to all was his recognition of the importance of selling style: what matters is not the commodity itself, but the lifestyle which, it is believed, can be gained from possessing that commodity. McLean moved across discrete spheres, ignoring distinctions between high and low art forms, and between advertising, mass media and art to demonstrate the degree to which all are subject to the dictates of fashion. For him art is subject to manipulation by the same pressures and forces that shape consumer culture as a whole. Style is the key, appearance is everything. The wit and panache with which he activated these perceptions discomfited even his staunch supporters, many of whom wish to segregate certain areas of his activity as 'valuable' in contradistinction to others felt to be collusive, or, at best, self-indulgent play. But as with Gilbert and George it was the totality of his activity that was crucial: not just the works themselves, but the image of the artist (as performer) and his methods of presentation (as interventions).

If, like Gilbert and George's, McLean's art took on a new relevance in the later seventies, it still had manifestly little to do with the questions central to sculpture. Ironically, it was the public controversy which erupted after the purchase by the Tate Gallery of Carl Andre's sculpture, 'Equivalent VIII' in 1976–the 'Bricks Affair' as it came to be known–which served to reunite the vanguard and raise the question of sculpture as object anew, and in highly apposite terms.[19] Two years later Andre's retrospective at the Whitechapel Gallery, his first substantial solo show in Britain, provided the occasion for a series of interviews and statements in which the American discussed his position in terms that related his practice to contemporary society, that affirmed his allegiance to a modernist tradition of sculpture, and that connected it to various current discourses while refusing to reduce it to a discursive content which rendered the

Carl Andre: *144 Magnesium Square,* 1969, installation view at Tate Gallery with works by Long, Fulton, Flanagan, Craig-Martin and Gilbert & George.

Michael Craig-Martin
Progression of 5 Boxes with Lids Reversed 1969

Bill Woodrow
Five Objects 1979–80

objecthood of the work otiose. Not only was Andre's aesthetic clear and cogent, but his highly articulate defence of it was something which few contemporary British sculptors could have matched. Since its tenets were to prove pertinent to many younger British sculptors, its key points deserve some elucidation. The sources for his materials were originally the street–'Scavenging the street, industrial sites and vacant lots is . . . how my practice evolved. If I become too remote from that I think that my work will lose whatever vitality it might have'[20]–and yet his choice of materials was intimately linked to questions relating to process and to composing, for in that conjunction meaning resided: 'I think works of art should refer [to] the *process* not the *appearance* of art' (my italics).[21]

Tony Cragg
New Stones: Newton's Tones 1978

Rejecting the idea of populist art, which he felt merely flattered its audience, Andre also shied away from the wider arena of conceptual art: 'I found that at the time in order to make a work of strength and conviction you could not do a scatter shot. You had to narrow your options . . . You could say that minimalism means tightening up ship, for me.'[22] The linguistic aspects of art were, to him, greatly overrated; art was not a sign but 'evidence', and thus 'as well as being a thing in the world, sculpture to be sculpture' had to 'have a demonstrable relationship with other works that we call sculpture.'[23]

Tony Cragg
Red Skin 1979

Several years previously Andre had outlined a history of twentieth century sculpture by means of a set of aphorisms, using as his example the changing interpretations of the Statue of Liberty, conceived originally (in the nineteenth century) primarily as a symbolic image: first it was read as form, then as structure, and thirdly, as place.[24] But now a fourth term was required; site was no longer just a physical locus it was also a socio-cultural space.[25] Andre's attitude to imagery was ambivalent–he accepted only reluctantly that all abstraction presented an 'image'–whereas the possibility of embracing its referential character more wholeheartedly appeared increasingly desirable to the younger sculptors.[26] Equally desirable was the possibility of amalgamating those aspects which had on Andre's account been successive stages in the history of modernist sculpture.

Recognising the limits inherent in modernist sculpture, these younger British artists adopted the idea of a gallery-based art which addressed the world in terms particular to that art, and not via theory or alternative discourses. Critical of both its own procedures and the social values that give authority to those procedures, modernist sculpture sets up a series of reflexive questions which serve to position the viewer and to provide a structure through which meaning can be created. Since

these younger artists wished to engage overtly and significantly with the contemporary world, they sought sometimes directly sometimes indirectly to confront its urban/industrial paradigms as Long did not, and to manipulate rather than simply be subject to the resulting iconography, as Andre did not.

In 1978 Tony Cragg made a sculpture, entitled tellingly 'New Stones: Newton's Tones', which in retrospect can be seen to pinpoint the critical turning point. Composed from plastic shards collected from the environs around the gallery, then laid out according to the colour spectrum, it radically alters the range of reference and signals the importance of subject matter while maintaining something of the attitudes to process and composition found in the work of both Andre and Long. It heralds those acts of reorientation and redefinition, but not straightforward rejection, that soon transformed the art of his peers. Since the interplay between the image and object, process and material was central to the way meaning was to be constructed, and since all languages were perceived to be metaphorical, an abstract hermetic art was ipso facto deemed impossible; for them, as for Cragg, no significant divisions exist between abstraction and representation. A comparison between, say, Andre's '144 Magnesium Square' (1969) and Cragg's 'Redskin' (1979), or between Michael Craig-Martin's 'Five Boxes' (1978) and Woodrow's 'Five Objects' (1979), demonstrates in broad terms the nature of the shift that took place in the work of these younger artists at the end of the seventies. In the former works, the content arises from a very simple lucid exposition, or from a twist on that declarative statement. In the latter the processes and procedures are still straightforward but the enacting of rational procedures is interrupted or subverted by intuitive decision-making or subsumed to the resulting imagery, and metaphor and metonymy now play a greater role. Nonetheless from the beginning of the eighties each of these so-called 'New British Sculptors' has construed the relationships between image and object, process and materials somewhat differently, putting the stress in different places.

Thus if this grouping is dubious so is the label, the 'New British Sculpture'. In certain essential ways this work is not new, it depends upon an allegiance to a notion and discipline of sculpture that has a considerable longevity. (Where it seeks newness it is not for its own sake but as a consequence of the belief that serious metaphysical statements can and must be made – though not necessarily in serious tones.) Moreover, since works by other sculptors living elsewhere, such as those by Harald Klingelhöller, could be discussed in

similar terms this art can be deemed British only by default, not design. The third word contains the key concept. Their deliberate embracing of a modernist conception of sculpture is very different from that return to the object which occured at virtually the same moment in the United States, as found in the work of Jeff Koons, where what is paramount is the role of the object as a commodity or product, and where the relationship between art-objects and other manufactured objects consequently becomes the principal concern. By contrast, the work of these British artists is unequivocally, self-confessedly sculpture: it affirms the possibility of using this mode, its traditions and forms, to significant ends, ends which are commensurate with – though, as the product of changing historical circumstances, necessarily different from – those to which it has been put in the past.[27]

NOTES

1. quoted in *Tony Cragg*, Arts Council of Great Britain, 1987, p.31

2. Several others, for various reasons sometimes of their own choice, are more peripheral: Edward Allington, Jean-Luc Vilmouth, Boyd Webb.

3. Cragg had a one-man show at the Arnolfini Gallery in Bristol in 1980, and again at Whitechapel in 1981; Woodrow, Deacon, Kapoor, Vilmouth and Gormley dominated *Objects & Sculpture*, held jointly at the ICA, London and Arnolfini Bristol also in 1981; and Houshiary and Wilding showed together at Kettles Yard in Cambridge early in 1982.

4. For example, they were grouped in *Englische Plastik Heute/British Sculpture Now*, Kunstmuseum Luzern, 1982; *Objects and Figures: Recent Developments in British Sculpture*, Fruitmarket Gallery Edinburgh in 1982; and *Transformations: New Sculpture from Britain*, XVII Bienal de São Paulo, 1983; and many subsequent shows. The importance in the early eighties of international group exhibitions which served to raise questions of national pedigree needs to be acknowledged, as does the fact that with the exception of Wilding, Gormley and Webb, all the others are part of the Lisson Gallery stable.

5. Klingelhöller's work was shown alongside that of Cragg, Deacon, Kapoor and Woodrow in *Juxtapositions: Recent Sculpture from England and Germany*, P S 1, Long Island City, New York, 1987.

6. Woodrow and Deacon studied at St Martin's School of Art; Cragg, Deacon, Webb, Wilding and Wentworth at the Royal College of Art; Woodrow, Kapoor and Houshiary at Chelsea: Gormley, exceptionally, attended Goldsmiths and the Slade schools of art, after a degree in anthropology at Trinity College, Cambridge.

7. For a fuller discussion of this see Simon Frith and Howard Horne, *Art Into Pop* (Methuen 1987, esp. pp. 27–29), who argue: "The art school is unique in British higher education. It condones and encourages an attitude to learning through trial and error, through day to day experiment rather than through instruction." In contradistinction to the usual practice of feeding students with the Romantic ideology of the artist as an inspired

individual preoccupied with notions of self expression, many of those who studied under Peter Kardia at either St Martin's or the Royal College, where he also taught, were encouraged to meet a set of criteria that were more demanding, aesthetically and ethically.

8. Webb came under considerable pressure at the Royal College when he refrained from producing objects for several terms. Although Deacon was enrolled in the experimental department of the Royal College and not on the sculpture course like Webb, Wilding, Wentworth and Cragg, he began making self-contained objects there as he had not previously as an undergraduate at St. Martin's.

9. See Charles Harrison, 'The late sixties in London and elsewhere', in *1965 to 1972–when attitudes became form*, Kettles Yard, Cambridge, 1984.

10. The principal magazines in which discussions of these issues from a British perspective took place were *Studio International*, and later, *Artscribe*.

11. The show was not quite as seamless as this suggests; Lucas Samaras was included, together with Robert Hudson who alone worked with ceramic, and David Nash whose aesthetic was, exceptionally, located in landscape.

12. Kapoor, Houshiary and Gormley all trained in the late seventies and so did not go through quite as protracted a period of forging an aesthetic.

13. quoted in *Tony Cragg*, op.cit., p.24

14. Gesture was described by Cragg as 'a little bit like a frozen moment'; its topicality meant that mostly it had a very limited duration. (*Tony Cragg*, op.cit., p.24).

15. Something of the ways in which process, in addition to materials, might signify is suggested in the following statement by Richard Deacon from 1985: 'I also think that putting one thing on top of another and joining them together by a piece that goes through them has connotations, as does laying one thing on top of another and gluing them together repeatedly. Those activities of construction have parallels with the ways in which we understand things in the world as having reference or meaning, whether as something applied to them or built-up or hidden. I think all those things are part of the constructive processes. I also think that making has some profound relationship to language. One of the prime functions of language is to describe or reform the world. It is something that is neither yours or mine, but is ours and lies between us and all of this stuff out there. Making is not dissimilar'. (quoted in *Entre El Objecto Y La Imagen*, The British Council, Madrid, 1986, p.233)

16. Deacon, for example, had always been receptive to some of Tucker's ideas as well as to those of certain American Minimalists, Cragg by contrast had looked to Andre as well as to Long: and many revered Beuys. The precedents of non-British artists from both the early and late sixties were always of importance.

17. This was the time of shows like *Art For Whom?* (Arts Council of Great Britain, 1978), and of some official concern that art reach a wider audience. Comparison needs to be made with certain of the strategies that the so-called Pop Situationalists made in the late seventies. (ref. Firth and Horne, op.cit.) Derek Jarman's work at this time betrays a similar approach, albeit one put to very different ends.

18. McLean described Nice Style as 'not theatre, not dance, not mime, not rock or art, but pose, a context of its own'. (quoted in Robert Hewison, *Too Much*, Methuen, London 1986, p.242)

19. The best discussion and defence was provided by Richard Morphet, of the Tate Gallery, in his article 'Carl Andre's Bricks', *The Burlington Magazine*, Nov. 1976, pp.762–767.

20. 'Carl Andre on his sculpture', *Artmonthly*, May & June 1978, reprinted in Peter Fuller, *Beyond the Crisis in Art*, London, 1980, p.120

21. Andre/Fuller, op.cit., p.127

22. Andre/Fuller, op.cit., p.119

23. Andre/Fuller, op.cit., p.127

24. quoted in *Carl Andre: Sculpture 1959–78*, Whitechapel Art Gallery, London, 1978, n.p.

25. Recognition of this need not undermine the self-reflexive character of art, as attested by Andre: 'Without the matrix of art, of culture there would be no reason to value the work'. (Andre/Fuller, op.cit., p.128)

26. Andre, who had been trying to reduce 'the image-making function of art to the least degree' realised that it was futile: 'You cannot absolutely remove the image'. He agreed with Fuller's claim that the work itself became an image of Late Modernism. (Andre/Fuller, op.cit., p.126) Compare this with Deacon's statement made in 1979 when he was on the verge of forging a referential imagery in his 'abstract' drawings: 'The drawings are intentionally extremely representational. I have difficulty in deciding of what they are representations. This concerns their reference. I have difficulty corroborating their reference with something. Except I have considered *Sonnets to Orpheus* as their subject'. (quoted in *Englische Plastik Heute*, op.cit., n.p.)

27. There is a danger here of overstating the degree to which some of these artists consciously address issues relating to sculpture as such, and the degree to which Modernist concepts play a part in their thinking. While the present author positions their work in relation to Late Modernism, this view is not necessarily held by all.

SCRATCH CULTURE

IAIN CHAMBERS

'I think it was Rilke who so lamented the inadequacy of our symbolism—regretted so bitterly we cannot unlike the (was it?) Ancient Greeks, find adequate external symbols for the life within us—yes, that's the quotation. But, no. He was wrong. Our external symbols must always express the life within us with absolute precision; how could they do otherwise, since that life has generated them? Therefore we must not blame our poor symbols if they take forms that seem trivial to us, or absurd, for the symbols themselves have no control over their own fleshy manifestations, however paltry they may be; the nature of our life alone has determined their forms.

A critique of these symbols is a critique of our lives.'

Angela Carter, *The Passion of New Eve*

THE END OF MEANING – ?

We live in a world of signs. From the Corn Flakes packet on the breakfast table to the 'Good Grease Guide' in *The Face*, and not forgetting the Perrier water 'with a twist of natural lime', *Eastenders*, video, seasonal fashions, the sounds, the sounds . . . the cross-indexed metropolitan 'look' and the endless text of advertising, we are confronted with the shifting, shiny surfaces of a wrap-around world.

According to the prophecies of the French writer Jean Baudrillard the ubiquitous presence of these signs betrays the ultimate exhaustion of meaning. They have seduced and abandoned us in an endless semiotic landscape where the call for meaning, the possibility of arresting and deciphering the signs, is permanently displaced. Their immediate allure screens us from the truth: beyond them there only exists the dead horizon of an infinite non-sense. Modern life has become a desert, without coordinates, a meaningless space. (Nonsense, however, as the French philosopher Gilles Deleuze reminds us, usually represents an excess, not an absence, of meaning.)

Signs once referred to something else; they stood in for, and guaranteed, a world of meaning located somewhere beyond (or behind) immediate appearances. Now they apparently refer merely to themselves. We are left not fully understanding them ('interpretation'), but simply playing with them.

Of course, Baudrillard's particular fascination with this 'play', and his own exhilarant nihilism in the face of this semantic black hole, is, in the end, itself only a sign. We are also free to choose others.[1]

Given the particular attention to signs, surfaces and appearances in both contemporary British sculpture and modern metropolitan culture in general I want briefly to suggest some of these signs.

PLASTIC HORIZONS

Both contemporary British sculpture and popular culture inhabit the city, and attempt to mould its materials and possibilities into a dialogue, a series of signs, a potential horizon of sense. In the case of sculpture – here I'm thinking in particular of the work of Bill Woodrow, Tony Cragg, Gilbert & George – I suppose what most strikes me is the fact that it is composed of bits which are recognizable as bits.

Items of junk, of effluence, of detritus, of displaced matter, have been assembled into emblems of the society that produced them. The disturbance and rearrangement of matter, the mutable nature of contemporary signs, and their subsequent assembling into a fresh collage and a possible reorganisation of sense, is what also characterises present day metropolitan culture. These shifting infections of the image open up a multi-vista of sense and a narrative foreground in which signs come increasingly to comment on themselves. Sculpture becomes less an individual and 'authentic' object and more an image whose 'tactile appropriation' (Walter Benjamin) represents part of the stories and narratives that comment on the surrounding sign world through the signs and images themselves. It is the immediacy of this collective work within

the sign, this implosive labour and sense, this plastic aesthetic ('ubiquity made visible', Roland Barthes), that now renders the rigid separation of the art world from other forms of sign production an all too obvious fiction. The former declines into the wider world.

STREET SIGNS

Postwar British subcultures are among the most spectacular demonstrations of the mutability of the contemporary sign. Whether it was the Teddy Boys borrowing imagery from Hollywood gangster movies and crossing it with a recycled Edwardian dandyism, or the Mods breaking out in a 'cool' (amphetamine induced) sweat as they calculatedly moved in the 'noon-day underground' of Tiles to the James Brown-motivated steps of the 'Block', male subcultures have continually appropriated the images and sounds of the surrounding consumer world (clothes, scooters, motorbikes, records) and publicly transformed them into styles that are also aesthetic statements about contemporary metropolitan living. In this exchange unsuspected use-values were revealed as these subcultural styles inadvertently transformed an aesthetics previously restricted to the worlds of the dandy and the *flâneur* into a popular, metropolitan style.

It has been their aesthetics, rather than their sociology, that has long outlived the actual demise of classical subcultures. Punk marked the outer limits of these classical subcultures. Subsequently, the temporary coherence of subcultures and their apparent establishment of homologies between signs (the assemblage of items that went into the subcultural 'style') and sense (a displaced, 'magical' solution to the experiences of working class culture) fell apart. The resulting fragments spilled over into the zone of semiotic metabolism.[2] Since then sharply defined subcultural styles tend to live out their invented existence either in mythological time (that of the 'traditional proletariat' for the skinheads) or in the abstract tempos of revivals ('teds' and 'mods' removed from the earlier contexts of post war–ration book–clothing coupon–Britain, or Carnaby Street and 'swinging London'). In so doing, they are fully coherent with the semiotic economy of the present: they are simply 'signs', no more, or less 'authentic' than the others in circulation.

In the semiotic uses popularised since punk there is a maximum intensity of signs and a minimum of meaning. Here description is immediately out-stripped by a bewildering display of inscriptions. The sign is emancipated (there is no one-to-one identity with a single referent or unique sense) and our overloaded bodies play with the resulting imagery without feeling obliged to acknow-ledge earlier rituals and customs. Previous orders of sense collapse into the fragmentary rhythms of semiotic slang; into the concrete com-(and per-) plexities of the contemporary world. The metropolitan eye and ear is increasingly accustomed to absorbing a myriad of elements, sounds, signs and sensations that are subsequently assembled into a shifting bricolage of sense. Resolution is replaced by the profane suggestion of dissolution.

THE OUTER LIMITS

It is from the limits, however, that an extensive awareness of the semiotic remakings of metropolitan experiences and aesthetics has tended to come. White male subcultures are only one example of the signs and suggestions for urban living that have arrived from those forced to live on the outer margins of political and cultural economies. In particular, it has been ethnic minorities and other subordinate cultures who have broadcast back to the centre the sounds of urban survival and local autonomies in the rhythmic languages of R&B, soul, disco, reggae, rap, salsa and scratch. The combinatory logic of these cultures, crossing cultural 'roots' with contemporary commercial and technological realities, has tended to be most closely tuned to the production of a modern aesthetics suitable for dialogue with the present.[3] Metropolitan margins and metropolitan languages – break culture and subway art – Naples, Italy:

When a 'Master Mixer' DJ in New York's Harlem like Grandmaster Flash cuts together previously recorded records and thereby establishes a new pulse, rhythm and sound ('that you've never heard before') he

effectively demonstrates that the dream of the avant-garde has been realized in the meta-phorical streets of our contemporary imagery and imagination. The aesthetics of shock, of the new, and a collage culture, are here all ironically exposed. Ironically, not only because Surrealism, Pop Art and Punk are now historical languages, but also because cinema, television and video have accustomed us to the perpetual flow and mutability of the image. There is no more 'pure state' of the new, no 'zero degree' of the image or sound, only the temporary surprise and fleeting novelty of fresh combinations of the 'already been'.

ART – ARTIFICE – ARTIFICIAL

All this suggests (at least this is one possi-bility) that 'culture', its art and aesthetics, is no longer a metaphysical entity, the bearer of timeless 'beauty' and 'truth'. Art wanders without a home in the secular world in which it is destined to non-conform, either with nostalgia for a ritual past or else confronting its own particular present and presence. The traditions of imagery (and their associated histories) are cracked open to be de- and re-signified. This constant re-cycling and re-contextualisation of objects, images and signs can suggest – whether borrowing from Brecht or the astonished vision sought in science fiction writing and film – the estrang-ement of the familiar that permits the possi-bility of a gesture towards other possible worlds.[4] Beyond the older institutional cate-gories of culture, politics and aesthetics there are now language contaminations, genre con-fusions, discursive scratching, image pirates, space invaders, aesthetic cannibals, and the widespread confusion of epistemology by questions of 'being'.

In this imaginary tourism the familiar is revisited through bricolage and assemblage or, going one step further, by focusing on details, extending and simulating them, blowing them up into a disorientating dis-order. Art is now a sign event, an interruption in the flow of the everyday and the taken-for-granted; it is no longer a separate ritual but an immediate image: the local site of possible senses. Like the scratch mixer taking snatches of sounds from surrounding soundscapes and stretching them, repeating them, cutting them up, mixing them together, contemporary art is a graffiti activity. Scratching across the surfaces of different her- and his-stories, re-elaborating, re-cycling and collaging the bits that go into the making of our metro-politan, increasingly global, languages, it seeks in multiple ways to in-scribe a sug-gestive shape on their movement.

The possibility of producing 'original' signs, of a fully separate, alternative and critical canvas or object on which to exper-iment and elaborate a fully formed project is lost. The passing away of that isolated and abstract perspective and the awakening to the more detailed and local complexities of our immediate circumstances is perhaps what most extensively characterises the contem-porary syntax of art, aesthetics and criticism. The sublime passes into the sign; we are finally free to participate in the secularised spectacle of mutable constructions.

At the centre of Fedora, a metropolis of grey stone, there is a metal building with a glass sphere in each of its rooms. Looking into each sphere one sees a blue city that is the model of another Fedora. They represent the form that the city might have taken if, for one reason or another, it had not become the object we see today. In every epoch, someone, seeing Fedora as it was, had imagined transforming it into an ideal city, but while he constructed his model in miniature Fedora had already changed, and what until yesterday had been a possible future was now only a toy in a glass sphere.
Italo Calvino, *Le Città invisibili.*

NOTES

1. It should be noted that Baudrillard's argument is deeply indebted to the fundamental metaphysical distinction between appearance and reality in which the former is a false, distorted, masked or incomplete version of the latter. In subordinating appearances to the second-order world of 'reality' the factor of meaning (or critical truth) is not locatable in the immediate context of appearances but in the subsequent, abstract and regulatory sphere of ideas. This Platonic *épisteme* and its theological construction of meaning, hence of aesthetics and the *polis*, is what eventually links the critical labours of Aristotle and Marx, Hegel and, ultimately, Baudrillard. It was the radical secularisation of critical thought–'God is dead'–proposed by the nineteenth-century German philosopher Friedrich Nietzsche, for whom appearance was 'the acting and living itself' and not a mask 'over an unknown x', that vigorously sought to break out of this tradition. Nietzsche, then, is another possible sign, opening up another possible set of readings.

2. It is the aesthetic logic of binding themselves to the contemporary world through temporarily imposing *their semiotic* sense on the signs of class, masculinity and consumer society that most stands out in considering the style of classical subcultures today.

3. Taking it from another, altogether less public, angle there is also the barely suspected production of a modern semantics that lies within women's magazines and the subsequent consumption/protagonism articulated around the mutable female 'I'. Janice Winship has recently published a stimulating survey of this world and its possibilities *Inside Women's Magazines* (London & New York: Pandora, 1987).

4. Science fiction has, of course, offered a privileged space for the exploration of possible worlds; a once extremely male genre, its contemporary use by feminist writers–Ursula LeGuin, Angela Carter, Joanna Russ, Margaret Atwood–should be noted here.

A list of group exhibitions precedes sections devoted to each artist or group. Each of the latter sections is divided into a list of solo exhibitions (with details of catalogues where known) and a bibliography. In cases where performances of publications *by* the artist or a group form a significant part of their work, these may be listed in separate sections.

GROUP EXHIBITIONS (CHRONOLOGICAL)

1972. Hayward Gallery, London. *The new art*. Illus. cat. 120pp. Text by A. Seymour. Organised by Arts Council of Great Britain.

1977. Art Institute of Chicago. *Europe in the Seventies: aspects of recent art*. Illus. cat. 119pp. Introd. by J C Ammann *et al*.

1979. Arts Council of Great Britain, London. *Langauges: an exhibition of artists using word and image*. Illus. cat. 52pp. Text by R H Fuchs. Touring exhibition opening in Glasgow, Third Eye Centre.

1979. Paris, Musée d'Art Moderne de la Ville de Paris. *Un certain art anglais . . , selection d'artistes britanniques 1970–79*. Illus. cat. 136pp. Text by M Compton *et al*.

1981. Institute of Contemporary Arts, London. *Objects & Sculpture*. Illus. cat. 39pp. Text by L Biggs *et al*. Simultaneously shown at Arnolfini, Bristol.

1981–82. Whitechapel Art Gallery, London. *British sculpture in the twentieth century*. Illus. bk. 264pp. Edited by S Nairne and N Serota.

1982. Kunstmuseum, Lucerne. *Englische Plastik heute / British sculpture now*. Illus. cat. 97pp. Text by M Kunz and M Newman.

1982. Metropolitan Art Museum, Tokyo. *Aspects of British art today*. Illus. cat. 207pp. Text by K Okamoto, D Brown. Organised by British Council.

1982–83. Fruitmarket Gallery, Edinburgh. *Objects & figures: new sculpture in Britain*. Illus. cat. 20pp. Text by M Newman. Organised by Scottish Arts Council.

1983. Centro d'Arte Contemporanea, Syracuse. *La trottola di Sirio*. Illus. cat. 32pp. Italian/English text by D Paparoni. Organised by British Council.

1983. John Hansard Gallery, Southampton. *Figures and objects: recent developments in British sculpture*. Illus. cat. 29pp. Text by M Newman.

1983. Hayward Gallery and Serpentine Gallery, London. *The sculpture show*. Illus. cat. 148pp. Organised by Arts Council of Great Britain.

1983. Tate Gallery, London. *New art at the Tate Gallery*. Illus. cat. 72pp. Text by M Compton.

1983. Bienal de São Paulo. *Transformations: new sculpture from Britain*. Illus. cat. 72pp. Travelling to Rio de Janeiro, Mexico D F and Lisbon. Organised by British Council.

1984. Museum of Modern Art, New York. *An international survey of recent painting and sculpture*. Illus. cat. 364pp.

1984. Tate Gallery, London. *The Turner Prize*. Illus. cat. 6pp. [also Tate Gallery catalogues for Turner Prize 1985, 1986, 1987.]

1984. City of Birmingham Museum and Art Gallery, and Ikon Gallery, Birmingham. *The British art show: old allegiances and new directions 1979–1984*. Illus. cat. 144pp. Text by J Thompson *et al*. Travelling to Edinburgh, Sheffield and Southampton. Organised by Arts Council of Great Britain. Publ. Orbis, London.

1985. Israel Museum, Jerusalem. *Three British sculptors: Richard Deacon, Julian Opie, Richard Wentworth*. Illus. cat. 36pp. Text by S Landau

1985. Art Gallery of Western Australia, Perth. *The British show*. Illus. cat. 160pp. Text by W Wright *et al*. Travelling to Sydney, Brisbane and Melbourne. Organised by British Council.

1985. Douglas Hyde Gallery, Dublin. *The poetic object*. Illus. cat 35pp. Text by R Francis. Travelling to Belfast.

1986. Palacio de Velazquez, Parque del Retiro, Madrid. *Entre el objecto y la imagen: escultura britanica contemporanea*. Illus. cat. 238pp. Text by L Biggs and J Munoz. Travelling to Barcelona. Organised by British Council.

1986. Louisiana Museum of Modern Art. Humlebaek. *Skulptur–9 kuntnere fra Storbritannien*. Illus. cat. 68pp. (as bulletin, *Louisiana Revy*, Mar 1986). Text by O Hjort *et al*.

1986. Tate Gallery, London. *Forty years of modern art 1945–1985*. Illus. cat. 120pp. Text by Ronald Alley.

1986. Hayward Gallery, London. *Falls the shadow: recent British and European art–1986 Hayward Annual*. Illus. cat. 116pp. Text by J Thompson and B Barker. Organised by Arts Council of Great Britain.

1987. Royal Academy of Arts, London. *British art in the 20th century: the modern movement*. Illus. cat. 457pp. Text edited by Susan Compton. Publ. Prestel-Verlag, Munich.

1987. Cornerhouse, Manchester. *Casting an eye*. Illus. cat. 6pp. Text by R Deacon, A Wilding.

1987. Museum of Contemporary Art, Chicago. *A quiet revolution: British sculpture since 1965*. Illus. cat. 188pp. Text edited by T A Neff. Travelling to San Fransisco, Washington and Buffalo. Publ. Thames and Hudson.

1987. Museum of Modern Art, Oxford. *Current affairs: British paintings and sculpture in the 1980s*. Illus. cat. 144pp. Text by L Biggs *et al*. Travelling to Budapest, Prague and Warsaw. Organised by British Council.

1987. Liljevalchs Konsthall, Stockholm. *Art: Brtittiskt 1980–tal*. Illus. cat. 140pp. Text by R Francis. Travelling to Tampere. Organised by British Council.

1987–1988. Brussels, Musée d'Art Moderne. *Viewpoint: hedendaagse Britse kunst/L'art contemporain en Grande Bretagne*. Illus. cat. 142pp. Text by Richard Cork *et al*.

ART & LANGUAGE

Solo Exhibitions

1967
Architectural Association, London, *Hardware show*.

1968
Herbert Art Gallery, Coventry. *VAT '68*
Ikon Gallery, Birmingham. *Dematerialisation show*.

1969
Pinacotheca Gallery, Melbourne.

1971
Dain Gallery, New York. *Tape show: exhibition of lectures*.
Galerie Daniel Templon, Paris.
Galleria Sperone, Turin.

1972
Galerie Daniel Templon, Paris. *Analytical art*.
Galerie Daniel Templon, Paris. *The Art & Language Institute*.
Galleria Daniel Templon, Milan. *Questionnaire*.
Paul Maenz, Cologne. *Documenta memorandum: (Indexing)*.
Visual Arts Gallery, New York. *The air conditioning show*.

1973
Galerie Daniel Templon, Paris. *Annotations*.
John Weber Gallery, New York. *Index 111*.
Lisson Gallery, London.
Paul Maenz, Cologne.

1974
Galerie Bischofberger, Zurich.
Galleria Schema, Florence.
Galleria Sperone, Turin.
Kunstmuseum Lucerne. *Art & Language*. Illus. cat. 43pp. Texts by Art & Language and J C Ammann.
MTL, Brussels.

1975
Art Gallery of New South Wales, Sydney. *New York ⟨–⟩ Australia*.
Galeria Foksal, Warsaw.
Gallery of the Students' Cultural Centre, Zagreb.
Lisson Gallery, London.
MTL, Brussels.
Museum of Modern Art, Oxford, *Art & Language, 1966–1975*.

1976
Auckland City Art Gallery. *Piggy-cur-Perfect*.
Galerie Eric Fabre, Paris. *Music-language*.
Galleria Schema, Florence. *Dialectical materialism*.
Ghislain Mollet-Vieville, Paris.
John Weber Gallery, New York. *Music-language*.
MTL, Brussels.

1977
Galleria Lia Rumma, Rome and Naples. *Music-language*.
Robert Self Gallery, London. *Illustrations for Art-Language*.

Robert Self Gallery, Newcastle upon Tyne. *see* Newcastle writings, 1977. *See* Publications by the Group, below.

1978
Cultureel Informatief Centrum, Ghent. *Flags for organisations.*
Galerie Association, Nice. *Art-Language.*
Lisson Gallery, London. *Flags for organisations.*

1979
Galerie Eric Fabre, Paris. *Ils donnent leur sang; donnez votre travail.*
Jan Sack, Antwerp. *Portraits of V I Lenin in the style of Jackson Pollock.*

1980
Leeds University Gallery. *Portraits of V I Lenin in the style of Jackson Pollock.*
Lisson Gallery, London. *Portraits of V I Lenin in the style of Jackson Pollock.*
Stedelijk van Abbemuseum, Eindhoven. *Portraits of V I Lenin in the style of Jackson Pollock.* Book published on the occasion of the exhibition, *see* Publications by the Group, below.

1981
Centre d'Art Contemporain, Geneva. *Portraits of V I Lenin in the style of Jackson Pollock.*
Galerie Eric Fabre, Paris. *Gustave Courbet's 'Burial at Ornans' expressing . . .*

1982
Musée de Toulon. *Art & Language: retrospective.* See Publications by the Group, below.
De Vleeshal, Middelburg. *Index: Studio at 3 Wesley Place painted by mouth.*

1983
Galerie Grita Insam, Vienna. *Index: Studio at 3 Wesley Place illuminated by an explosion nearby, VII, VIII.*
Gewad, Ghent. *Index: Studio at 3 Wesley Place, I, II, III, IV.*
Ikon Gallery, Birmingham. *Art and language.* See Publications by the Group, below.
Institute of Contemporary Art, Los Angeles. *Art & Language.* Illus. cat. 50pp. Text by R L Smith. Incl. transcript of seminar held.Ikon Gallery, Birmingham, 26 May 1983.
Lisson Gallery, London. *Index: Studio at 3 Wesley Place illuminated by an explosion nearby, V, VI.*

1985
Tate Gallery, London. *Studies for The Studio at 3 Wesley Place.*

1986
Lisson Gallery, London. *Art & Language: confessions – incidents in a museum: paintings by Michael Baldwin and Mel Ramsden.* Illus. cat. 32pp. Text by C Harrison.

Publications by the Group.
Published writings by the Group are too numerous to list here, but bibliographies will be found in the Eindhoven (1980) and Toulon (1982) publications noted below. The following is a highly select list of anthologies of the Group's theoretical writings.

Art and language: catalogue raisonné, November 1965-February 1969. The Press with Galerie Bischofberger, Zurich, [1969?].

Art & Language (Periodical). Vol 1, no 1, May 1969–vol 5, no 3, Mar 1985.

Analytical art. (Periodical); ed. by K. Lole, P. Pilkington and D. Rushton. Coventry: Analytical Art Press, 1971–1972. 2 issues 1971, 1972.

P Maenz and G de Vries (eds). *Art & Language: Texte zum Phänomen Kunst und Sprache.* Cologne: DuMont, 1972.

Art and Language. [Selected essays], in *On art/Über Kunst,* edited by G de Vries. Cologne: DuMont-Schauberg, 1972.

Art & Language, 1966–1975: selected essays. Oxford: Museum of Modern Art, 1975.

The Fox. (Periodical). No 1, Mar 1975–No 3, Apr 1976. New York: Art & Language.

Newcastle writings 1977. London: R. Self in assoc. with Northern Arts, 1977. On the occasion of an exhibition.

Art & Language, 1975–1978: Selected essays. Paris: E Fabre, 1978. French/English ed.

Art & Language. *Art & Language: [collected works].* Eindhoven: Van Abbemuseum, 1980. Book published on the occasion of an exhibition.

Art & Language. *Art & Language.* Trans. and with text by C. Schlatter. Toulon: Musée de Toulon, 1982. French/English text.

Art and Language. *Art & Language.* Birmingham: Ikon Gallery, 1983. Published on the occasion of an exhibition, May–June 1983. Contents: *The orders of discourse: the artist's studio,* by C. Harrison, (ed. version of Lecture VI. of Durning-Lawrence Lectures delivered University College, London, Nov-Dec 1982); *Art & Language paints a picture: a fragment.*

Art & Language. 'Portrait of V. I. Lenin' 'Abstract Expressionism', 'Author and Producer Revisited', in *Modernism, criticism, realism,* ed. by C Harrison and F Orton. London; New York: Harper & Row, 1984. pp145–69; 191–204; 251–9.

Bibliography (writings about the Group)

B Boice. Books: Art & Language. *Artforum,* Mar 1973, pp86–7.

T Smith. Art and Art and Language. *Artforum,* Feb 1974, pp49–52.

P Wood. 'Art-Language' at the Lisson Gallery. *Studio International,* Feb 1974, pp51–2.

I Burn. The art market: affluence and degradation. *Artforum,* Apr 1975, pp34–7.

P Groot. Art & Language: guerrillos van de kunstwereld. *Museumjournaal,* no 5/1980, pp194–9.

C Harrison and F Orton. *A provisional history of Art & Langauge.* Paris: E Fabre, 1982.

J Roberts. Three men in a studio. *Art Monthly,* no 68, July/Aug 1983, pp11–12.

S Miller. Art & Language: Mike Baldwin and Mel Ramsden: extracts from a conversation. *Artscribe,* no 47, July/Aug. 1984, pp13–18.

D Kuspit. Of Art and Language. *Artforum,* May 1986, pp127–9.

R Francis. Your 'if' is the only peacemaker . . . Art & Language's museum paintings. *Artscribe,* no 58, June/July 1986, pp22–6.

TONY CRAGG

Solo Exhibitions

1970
Künstlerhaus Weidenallee, Hamburg.
Lisson Gallery, London
Lutzowstrasse Situation, Berlin.

1979
Lisson Gallery, London.

1980
Arnolfini Gallery, Bristol.
Chantal Crousel, Paris.
Franco Toselli, Milan.
Konrad Fischer, Düsseldorf.
Lisson Gallery, London.
Lucio Amelio, Naples.
Lutzowstrasse Situation, Berlin.
Saman Gallery, Genova.

1981
Front Room, London.
Musée d'Art et d'Industrie, Saint-Etienne. *Tony Cragg.* Illus. cat. 24pp.
Nouveau Musée, Lyon/Villeurbanne.
Schellman & Klüser, Munich.
Vacuum, Düsseldorf.
Von der Heydt-Museum, Wuppertal. *Tony Cragg.* Illus. cat. 8pp. Text by U Peters
Whitechapel Art Gallery, London. *Tony Cragg: Sculpture.* Illus. cat. 4pp. Text by M Francis.

1982
Bädischer Kunstverein, Karlsruhe. *Tony Cragg: Skulpturen.* Illus. cat. 48pp. Text by M Newman.
Büro, Berlin.
Chantal Crousel, Paris.
Kanrasha Gallery, Tokyo.
Konrad Fischer, Düsseldorf.
Lisson Gallery, London. *Tony Cragg: sculpture.* Folded card 4pp; Dupl. typescript. 4pp. Text by the artist.
Marian Goodman, New York.
New Delhi Triennale. *Tony Cragg.* Illus. cat. 16pp. Text by N Lynton. Organised by British Council.
Nisshin Gallery, Tokyo.
Nouveau Musée, Lyon/Villeurbanne.
Rijksmuseum Kröller-Müller, Otterlo. Cat.
Schellmann & Klüser, Munich.

1983
Art & Project, Amsterdam.
Franco Toselli, Milan.
Galerie Buchmann, St Gallen. Book published, *see* Bibliography.
Kunsthalle Berne. *Tony Cragg.* Illus. cat. 99pp. Texts by J H Martin, G Celant and the artist.
Lucio Amelio, Naples.
Marian Goodman, New York.
Thomas Cohn, Rio de Janiero.

1984
Art & Project, Amsterdam. *Tony Cragg.* Catalogue published as *Art & Project Bulletin,* no 141.
Crousel-Hussenot, Paris.

De Vleeshal, Middelburg.
Galleria Tucci Russo, Turin.
Kanrasha Gallery, Tokyo.
Kölnischer Kunstverein. *Tony Cragg: Vier Arbeiten, 1984.*
Illus. cat. 16pp.
Louisiana Museum of Art, Humlebaek.
Marian Goodman, New York.
Schellmann & Klüser, Munich.
Yarlow & Salzmann, Toronto.

1985
Art & Project, Amsterdam.
Donald Young Gallery, Chicago.
Galerie Bernd Klüser, Munich.
Kunsthalle, Berne. Cat.
Kunsthalle Waaghaus, Winterthur.
Lisson Gallery, London. *Tony Cragg: recent works: 1984–1985.* Dupl. typescript. 1pp.
Palais des Beaux-Arts, Brussels. *Tony Cragg.* Illus. Cat.
104pp. Text by A. Pohlen. Interview. Travelling to
Paris.
Staatsgalerie Moderner Kunst, Munich.

1985–1986
Kestner-Gesellschaft, Hanover. *Tony Cragg: Skulpturen.*
Illus. cat. 90pp. Texts by C Haenlein and the artist.

1986
Brooklyn Museum, New York.
Galerie Buchmann, Basle.
Tate Gallery, Liverpool. *Events Summer 1986. . . Tony
Cragg: a sculpture. . .* Illus. cat. 32pp. Text by R. Francis.
University Art Museum, University of California,
Berkeley. Cat. Travelling to La Jolla.

1987
Hayward Gallery, London. *Tony Cragg.* Illus. cat. 80pp.
Text by L Cooke. Organised by Arts Council of Great
Britain.

Bibliography

B Jones. A new wave in sculpture: a survey of recent
work by ten younger sculptors: New prospectors:
Shelagh Wakely and Tony Cragg. *Artscribe*, no 8, Sept
1977, p16.

L Biggs. Tony Cragg. *Arnolfini Review*, May/June 1980,
p5.

S Morgan. Tony Cragg, Lisson Gallery (London,
England). *Artforum*, Oct 1980, p86.

L Ponti. Tony Cragg. *Domus*, no 611, Nov 1980,
pp50–1.

L Cooke. Tony Cragg at the Whitechapel. *Artscribe*,
no 28. Mar 1981, pp54–5.

G Celant. Tony Cragg and industrial Platonism.
Artforum, Nov 1981, pp40–6.

J-L Maubant. Découpage/Collage à propos de Tony
Cragg. *Cahiers du CRIC*, (Le Nouveau Musée/NDLR),
no 4, May 1982. Limoges: Centre de Co-ordination,
Recherche & Intervention Culturelles.

A Wildermuth. Tony Cragg: zwei Landschaften. Basle:
Galerie Buchmann, [1983].

C Stellweg. Tony Cragg [at] Marian Goodman.
Art News, Summer 1983, p194.

P Winter. Tony Cragg: Puzzlespiel und Superzeichen.
Kunstforum, no 62, June 1983, pp56–65.

B Hatton. Junk Culture: the uses of affluence. *ZG*, [no 9,
Sept 1983], 2pp.

P Turner. *Tony Cragg's 'Axehead'*. London: Tate Gallery,
1984.

B Welter. Beeldhouwen met gruis. *Metropolis M*,
no 3/1985, p52.

L Rogozinski. Tony Cragg, Galleria Tucci Russo:
(Turin). *Artforum*, Mar. 1985, p107.

J Russi Kirshner. Tony Cragg, Richard Deacon [at
Donald Young Gallery], (Chicago). *Artforum*, Summer
1985, p113.

I Lemaître. Interview with Tony Cragg. *Artefactum*, Nov
1985/Jan 1986, pp7–11.

A Pohlen. Tony Cragg [at] Kestner-Gesellschaft
(Hanover). *Artforum*, May 1986, pp148–9.

N Princenthal. Tony Cragg at Marian Goodman. *Art in
America*, June 1986, p127.

J McEwen. Tony Cragg at the Hayward. *Art in America*,
July 1986, pp36–7.

MICHAEL CRAIG-MARTIN

Solo Exhibitions

1969
Rowan Gallery, London. *Michael Craig-Martin: sculpture.*
Illus. card; dupl. typescript.

1970
Rowan Gallery, London. *Michael Craig-Martin: recent
sculpture.* Illus. card; dupl. typescript.

1971
Arnolfini Gallery, Bristol. *Michael Craig-Martin.* 4pp.
folded card.
Richard Demarco Gallery, Edinburgh.

1972
Rowan Gallery, London. *Michael Craig-Martin: new work.*
Illus. card; duplicated typescript.

1973
Rowan Gallery, London. *Michael Craig-Martin: new work.*
Illus. card; duplicated typescript.

1974
Galerie December, Munster.
Rowan Gallery, London. *Michael Craig-Martin.* Cat. 4pp.
Interview with the artist.

1975
Rowan Gallery, London. *Michael Craig-Martin: drawings/
signs/films.* Card; duplicated typescript.

1976
Arnolfini Gallery, Bristol. *Michael Craig-Martin: selected
works, 1966–1975*, [with David Hockney]. Illus. cat. 8pp.

Rowan Gallery, London. *Works by Michael Craig-Martin.*
Illus. card; duplicated typescript.

Turnpike Gallery, Leigh. *Michael Craig-Martin: selected
works, 1966–1975.* Illus. cat. 36pp. Travelling exhibition.

1977
Oliver Dowling, Dublin. *Michael Craig-Martin: 'An oak
tree'.* 4pp. illus. cat.

1978
Australian touring exhibition. *Michael Craig-Martin:
10 works 1970–1977.* Co-organised by the British Council.
Galerie December, Münster.

1979
Galeria Akumulatory, Poznan.
Galeria Foksal, Warsaw.
Oliver Dowling Gallery, Dublin.

1980
Galerie Bama, Paris.

1981
Galerija Suvremene Umjetnosti, Zagreb. *Michael
Craig-Martin: [wall-drawings].* Illus. cat. Text by the
artist.

1982
New Delhi Triennale. *Michael Craig-Martin: [tape
installation].* Text by N Lynton. Organised by British
Council. 16pp. illus. cat.
Waddington Galleries, London. *Michael Craig-Martin:
constructions and wall drawings.* Folded card 4pp. dupl.
typescript.

1984
Waddington & Shiell Galleries, Toronto.

1985
Waddington Galleries, London. *Michael
Craig-Martin.* Text by R. Shone. 28pp. illus. cat.

Bibliography

S Field. London one: [Michael Craig-Martin at Rowan
Gallery]. *Art and Artists*, Sept 1969, pp48, 50.

R Morphet. London commentary: [Michael
Craig-Martin at the Rowan Gallery]. *Studio International*,
Sept 1969, pp86–7.

W Packer. London exhibitions . . . Rowan Gallery,
Michael Craig-Martin. *Art and Artists*, Sept 1970, p29.

G Burn. Craig-Martin [at the Rowan Gallery]. *Arts
Review*, 12 Sept 1970, p580.

Michael Craig-Martin. A procedural proposition:
selection, repetition, extension, exchange. *Studio
International*, Sept 1971, pp76–9.

P Dormer. Michael Craig-Martin: Tate Gallery and
Rowan. *Arts Review*, 11 Mar 1972, p143.

W Packer. London: [Tate Gallery and Rowan Gallery].
Art and Artists, Apr 1972, p45.

S Field. Michael Craig-Martin: an interview. *Art and
Artists*, May 1972, pp26–31.

R Shone. Michael Craig-Martin, Rowan Gallery. *Arts
Review*, 16 June 1973, p413.

An interview with Michael Craig-Martin. *Audio Arts*, vol
1, no 1, 1974, side 1, track 1.

C Faure Walker. Michael Craig-Martin at the Rowan
Gallery, London. *Studio International*, June 1974, p312.

T del Renzio. Art &/or language. *Art and Artists*, Dec 1975, pp10–13.

Michael Craig-Martin. Taking things as pictures. *Artscribe*, no 14, Oct 1978, pp14–15.

A Searle. Michael Craig-Martin, Paul Huxley at the Rowan. . . *Artscribe*, no 15, Dec 1978, p54–5.

R Shone. London, Rowan Gallery, Michael Craig-Martin. *Burlington Magazine*, Mar 1980, pp214–215.

R Shone. London exhibitions: [Michael Craig-Martin at Waddington]. *Burlington Magazine*, Feb 1983, p110.

RICHARD DEACON

Solo Exhibitions

1975
Royal College of Art Galleries, London.

1976
Royal College of Art Galleries, London.

1978
The Gallery, Brixton, London.

1980
The Gallery, Brixton, London.

1981
Sheffield City Polytechnic Gallery. *Sculptures by Richard Deacon*. Illus. card 2pp. dupli. typscrpt.

1983
Lisson Gallery, London.
Orchard Gallery, Londonderry. *Richard Deacon: sculpture*. Illus. cat. [16]pp. Text by L Cooke.

1984
Chapter Arts Centre, Cardiff. 'Book' published on the occasion of the exhibition, *see* Bibliography.
Fruitmarket Gallery, Edinburgh. *Richard Deacon: sculpture 1980–1984*. Illus. cat. 47pp. Text by M Newman. Travelling to Lyon/Villeurbanne.
Riverside Studios, London. *Richard Deacon: new sculpture*. dupl. typscrpt 3pp.; 3 postcards.

1985
Serpentine Gallery, London.
Tate Gallery, London. *Richard Deacon*. Illus. cat. 6pp. Text by R Francis.

1986
Interim Art, London.
Marian Goodman Gallery, New York.

1986–1987
Arts Centre, Aberystwyth. *For those who have eyes: Richard Deacon sculpture*. Illus. cat. [24]pp. Text by the artist. Travelling to Swansea, Cardiff, Llandudno, London and Stoke-on-Trent.

1987
Lisson Gallery, London. *Richard Deacon*. Dupl. typscrpt. 1pp.

1988
Lisson Gallery, London *Richard Deacon: prints and drawings*. Dupl. typscrpt. 5pp.

Bibliography

Richard Deacon. Notes on a piece of sculpture. *Journal from the Royal College of Art*, no 1, Jan 1977, pp54–7.

L Cooke. Carolyne Kardia at Felicity Samuel, Richard Deacon at the Gallery, Brixton. *Artscribe*, no 24, Summer 1980, pp53–4.

C Faure Walker. Richard Deacon talking with Caryn Faure Walker. *Aspects*, no 17, Winter 1982, pp[11–22].

L Cooke. Richard Deacon, Lisson Gallery. *Art Monthly*, no 64, Mar 1983, pp16–17.

M Donnelly. Richard Deacon – sculpture, Orchard Gallery, Derry. . . *Circa*, no 11, July/Aug 1983, pp23–5.

Richard Deacon. Stuff box object 1971/2. Cardiff: Chapter (Cardiff) Ltd, 1984.

Richard Deacon. Statements: Richard Deacon. *Link*, no 39, July/Aug 1984, p6.

L Cooke. Richard Deacon at Riverside Studios, (London). *Art in America*, Sept 1984, p225.

G. Van Hensbergen. Richard Deacon: organische constructies. *Metropolis M* (Amsterdam), no 3, 1985, pp16–21.

P E Bickers. A conversation with Richard Deacon. *Art Monthly*, no 83, Feb 1985, pp17–18.

M Newman. Richard Deacon: la face des choses. *Art Press*, no 90, Mar 1985, pp26–31.

J Russi Kirshner. Tony Cragg, Richard Deacon [at Donald Young Gallery], (Chicago). *Artforum*, Summer 1985, p113.

Blind, deaf and dumb: sculpture, architecture and film come together in an exhibition at the Serpentine Gallery. *Building Design*, 4 Oct 1985, pp17–23.

O Kaeppelin. Richard Deacon: comme un oiseau. *Opus International*, no 102, Autumn 1986, pp40–1. French text.

B Adams. Richard Deacon at Marian Goodman. *Art in America*, Jan 1987, pp130–1.

M R Beaumont. Richard Deacon: Lisson Gallery. *Arts Review*, 10 Apr 1987, p235.

J Cornall. Very like a whale: meaning in the sculpture of Richard Deacon. *Alba*, no 6, Winter 1987, pp21–5.

BARRY FLANAGAN

Solo Exhibitions

1966
Rowan Gallery, London. *Barry Flanagan: sculpture*. Illus. folded card, [4]pp.

1968
Galerie Ricke, Kassel. *Barry Flanagan: Environment Skulpturen*. Travelling to Milan and Turin. Illus. card.
Rowan Gallery, London. *Barry Flanagan: recent sculpture*. Illus. card.

1969
Fischbach Gallery, New York.
Museum Haus Lange, Krefeld. *Barry Flanagan: Object Sculptures*. 32pp. illus. cat. Text by Paul Wember.

1970
Rowan Gallery, London. *Barry Flanagan: recent work*. Illus. card.

1971
Galleria del Leone, Venice.
Rowan Gallery, London. *Flanagan*. Card.

1972
Rowan Gallery, London. *Barry Flanagan: homework*. Card; typscrpt. 2pp.

1973
Rowan Gallery, London. *Barry Flanagan*. Illus. card; typscrpt.

1974
Bluecoat Gallery, Liverpool. *Exhibition of small works*. Illus. cat 4pp.
Galleria dell'Ariete, Milan. *Drawings*.
Museum of Modern Art, New York. Part of the *Projects* series.
Museum of Modern Art, Oxford. *Barry Flanagan: drawings 1966–1974*.
Rowan Gallery, London. *Something Etruscan*. Illus. card; dupl. typscrpt. 2pp.

1975
Art & Project, Amsterdam. *Barry Flanagan: coil, pinch and squeeze pots*. Catalogue published as *Art & Project Bulletin*, no 93.
Hogarth Galleries, Sydney.

1976
Centro de Arte y Communicacion, Buenos Aires.
Hester van Royen, London.

1977
Appeldorn Museum, *Graphics*.
Art & Project, Amsterdam. *Barry Flanagan: light pieces*. Catalogue published as *Art & Project Bulletin*, no 104.
Hester van Royen, London. *Ceramics*.
Van Abbemuseum, Eindhoven. *Barry Flanagan: [sculpture 1965–1976]*. illus. cat. 32pp. Text by C Lampert. Travelling to Bristol and London.

1978/1979
Serpentine Gallery, London. *Barry Flanagan: sculpture 1965–1978*. [4]pp. card and 1pp. duplicated typscrpt. Text by C Lampert. (Touring show from Eindhoven).

1980
Galerie Durand-Dessert, Paris.
New 57 Gallery, Edinburgh. *Barry Flanagan*. Illus. cat. 16pp. Text by D Brown.
Waddington Galleries II. *Barry Flanagan: sculptures in stone 1973–1979*. Illus. cat. 40pp. Text by C Lampert.

1981
Mostyn Art Gallery, Llandudno. *Sixties and seventies: prints and drawings by Barry Flanagan*. illus. cat. 16pp. Text by C Lampert. Travelling in Wales and to Southampton and London.
Waddington Galleries, London. *Barry Flanagan: sculptures in bronze 1980–1981*. Illus. cat. 36pp.

1982
Galerie Durand-Dessert, Paris.
Venice Biennale. *Barry Flanagan: sculpture*. Illus. cat.

96pp. Texts by T Hilton and M Compton. Organised by the British Council. Travelling to Krefeld and Whitechapel Art Gallery, London.

1983
British Council, London. *Barry Flanagan: stampe e disegni/ prints and drawings.* Illus. cat. 16pp. Text by C Lampert. Travelling to Syracuse, Capri, Naples and Gouda. Originating in Llandudno 1981.
Centre Georges Pompidou, Paris. *Barry Flanagan: sculptures.* illus. cat. 95pp. Texts by C Lampert and B Blistene. Organised by the British Council.
Pace Gallery, New York. *Barry Flanagan: recent sculpture.* illus. cat. 44pp. Text by M Compton.
Waddington Galleries, London.

1984
Waddington Graphics. *Barry Flanagan: etchings and linocuts.* Illus. cat. 24pp. Text by D Brown.
Whitechapel Art Gallery, London. (from Venice Biennale).

1985
Richard Gray Gallery, Chicago. *Barry Flanagan: new sculpture.* Illus. card; Folded sheet, 4pp.
Waddington Galleries, London. *Barry Flanagan.* Illus. cat. 26pp.

1986
Tate Gallery, London. *Barry Flanagan: prints 1970–1983.* illus. cat. Text by E Knowles.

1987
Laing Art Gallery, Newcastle upon Tyne. *Barry Flanagan: a visual invitation – sculpture 1967–1987.* Illus. cat. 72pp. Text by L Biggs.

Bibliography

Barry Flanagan (compiler). Silence, no 1 (1964) – no 16 (June 1965). London: printed at St Martin's School of Art, Sculpture Department. (Some issues have title: Silêns.)

C Maddox, Barry Flanagan: Rowan Gallery. *Arts Review,* 6 Aug 1966, p371.

G Baro. Animal, vegetable and mineral. *Art and Artists,* Sept 1966, pp62–3.

Barry Flanagan writes. *ICA Bulletin,* Nov 1966, p9.

British artists at the Biennale des Jeunes in Paris . . . (with a statement by Barry Flanagan). *Studio International,* Sept 1967, pp85, 98–9.

Barry Flanagan. Eyeliners: some leaves from Barry Flanagan's notebook. *Art and Artists,* Apr 1968, pp30–3.

C Harrison. Barry Flanagan's sculpture. *Studio International,* May 1968, pp66–8.

Barry Flanagan. From notes, 67/8. *Studio International,* Jan 1969, p37.

Barry Flanagan. An old New York letter. *Studio International,* May 1969, p208.

Barry Flanagan. A literary work. *Studio International,* July/Aug 1969, p4.

G Baro. Sculpture made visible: Barry Flanagan in discussion. *Studio International,* Oct 1969, p122–5.

P Fuller. Barry Flanagan: Rowan Gallery. *Arts Review,* 11 Apr 1970, pp217, 231.

Barry Flanagan. in 48 page exhibition. *Studio International,* Jul 1970, p29.

Barry Flanagan and P Fuller. Barry Flanagan: sculptor: a statement. *Connoisseur,* Jul 1970, p210.

Sculptures by . . . Barry Flanagan. *Studio International,* May 1971, pp217–19. Illus. only.

J Rees. Cambridge [Laundress Green sculpture, Peter Stuyvesant City Sculpture Project '72 and press reaction]. *Studio International,* July/Aug 1972, pp15,19,32–7.

R Brooks. Barry Flanagan & Richard Long: 2nd phase minimalism. *Flash Art,* no 44/45, Apr 1974, pp40–1.

C Lampert. Barry Flanagan, 'Drawings 1966/1974' at the Museum of Modern Art, Oxford. *Studio International,* Dec. 1974, Review section, p12.

V Reed. Barry Flanagan. (Biennale 75). *Art Press,* Sept/ Oct 1975, p19. French text.

C Adams. Barry Flanagan: [including interview]. *Arnolfini Review,* July/Aug. 1977, p5.

C Lampert. Barry Flanagan. *Artistes,* no 2, Dec. 1979/Jan 1980, pp10–17. French text.

A Rose. Paschal lambs and March hares: [Craigie Aitchison and Barry Flanagan]. *London Magazine,* Mar 1982, pp72–6.

J. Glaves-Smith. Barry Flanagan: the role of parody and irony. *Art Monthly,* no 58, July/Aug 1982, pp5–6.

L Cooke. London: Barry Flanagan at the Whitechapel and at Waddington *Art in America,* Mar 1983, p167.

C Francblin. Barry Flanagan: la sculpture en état d'apesanteur. *Art Press,* no 68, Mar 1983, p18–20. French text.

L Peters. Barry Flanagan. *Arts Magazine,* Jan. 1984, p2.

Barry Flanagan. Dessins. *Noise,* no 5, [Sept] 1986, pp10–15. French text.

HAMISH FULTON

Solo Exhibitions

1969
Konrad Fischer, Düsseldorf.

1970
Gianenzo Sperone, Turin.

1971
Konrad Fischer, Düsseldorf.
Richard Demarco, Edinburgh.
Situation, London.

1972
Art & Project, Amsterdam. *Hamish Fulton: walking the Pekisko Road, Alberta.* Catalogue published as *Art & Project Bulletin,* no 52.
Franco Toselli, Milan.
Konrad Fischer, Düsseldorf.
Museum of Modern Art, Oxford.
Yvon Lambert, Paris.

1973
Art & Project, Amsterdam.
Kabinett für Aktuelle Kunst, Bremerhaven.
MTL, Antwerp.
Situation, London.
Sperone-Fischer, Rome.
Stedelijk Museum, Amsterdam. *10 views of Brockmans Mount: a naturally formed hill near Hythe, Kent, England.* Illus. artist's book, 22pp.
Yvon Lambert, Paris.

1974
Gianenzo Sperone, Turin.
Konrad Fischer, Düsseldorf.
Marilena Bonomo, Bari.
Museum of Modern Art, Oxford. *Hamish Fulton.* dupl. typscrpt. [1]pp.

1975
Art & Project, Amsterdam *Hamish Fulton: game trails in the Rockies.* Catalogue published as *Art & Project Bulletin,* no 86.
Kunstmuseum, Basle. [*16 selected walks*].
Northern Arts, Newcastle.
P M J Self, London. Book published on the occasion of the exhibition, *see* Publications by the Artist.
Rolf Preisig, Basle.

1976
Claire Copley, Los Angeles.
Cusak, Houston.
I C A, London.
Hester van Royen, London.
Massimo Valsecchi, Milan
Robert Self, London.
Sperone Westwater Fischer, New York.

1977
City Museum, Canterbury.
Ileana Sonnabend, New York.
Robert Self, London. Artist's book published on the occasion of the exhibition, *see* Publications by the Artist.
Rolf Preisig, Basle.
Stedelijk van Abbemuseum, Eindhoven. *Nepal, 1975.* [18]p. illus. artist's book.

1978
Centre d'Art Contemporain, Geneva.
Gillespie de Laage, Paris.
Konrad Fischer, Düsseldorf.
Museum of Modern Art, New York.
Tanit, Munich.

1979
Art & Project, Amsterdam. *Hamish Fulton: the challenge.* Catalogue published as *Art & Project Bulletin,* no 109.
Rolf Preisig, Basle.
Whitechapel Art Gallery, London. *Hamish Fulton: selected walks.* Cat [4]pp.

1980
Gillespie de Laage, Paris.
Graeme Murray, Edinburgh.
Kanransha, Tokyo.
Sperone Westwater Fischer, New York.
Thackerey & Robertson, San Fransisco.
Waddington, London.

1981
Centre Georges Pompidou, Paris. *Wild flowers = fleurs sauvages: a seven day walk in the Pyrenees.* [4]pp. illus. artist's book.
Massimo Valsecchi, Milan.

1982
Orchard Gallery, Londonderry.
Waddington, London, Book published on the occasion of the exhibition, *see* Publications by the Artist.

1983
Coracle, London.
Gillespie de Laage Salomon, Paris.
John Weber, New York.
Kanransha, Tokyo.
Massimo Valsecchi, Milan.
Musée d'Art Contemporain, Bordeaux. *Twilight horizons: a twenty day walking journey from Dumre to Leder in Manang and back to Pokhara by way of Khudi, Nepal, early 1983.* Illus. artist's book, 40pp. Published by Coracle Press, London, for the museum.

1984
Centre d'Art Contemporain, Geneva.
Waddington, London. *Hamish Fulton: recent work.* Dupl. typscrpt. [1]pp.

1985
Coracle, London.
Fruitmarket, Edinburgh.
John Weber, New York.
Mendel Gallery, Saskatoon.
Nouveau Musée, Lyon/Villeurbanne.
Stedelijk van Abbemuseum, Eindhoven. *Camp fire.* Illus. artist's book, [114]pp. Exhibition touring.

1986
Castello di Rivoli, Turin.
Dietmar Werle, Cologne.
Galerie Tanit, Munich. *3 four day walks in Hokkaido. . . 1983.*
Gillespie de Laage Salomon, Paris.
Kanransha, Tokyo.

1987
Victoria Miro, London.

Publications by the Artist

Some books published on the occasion of exhibitions, appear under 'Solo Exhibitions'.

Hollow Lane. London: Situation Publications, [1971].

The sweet grass hills of Montana (Kutoyisiks) as seen from the Milk River of Alberta (Kinuk Sisakta). [Turin: Sperone, 1971.]

Hamish Fulton. Milan: Galleria Franco Toselli, 1974.

Skyline Ridge. London: P M J Self, 1975.
Nine works, 1969–73. London: R Self, 1977.

Roads and paths: twenty walks, 1971–1977 and eight photographs of roads. Munich: Schirmer-Mosel, 1978.

Song of the skylark. London: Coracle Press, for Waddington Galleries, 1982.

Horizon to horizon. London, Coracle Press for Orchard Gallery, 1983.

Kestrels daylight. Furor, no 13, Feb 1985, pp43–63.

Four nights camping in a wood. Neuss: Insel Hombroich, 1987.

Bibliography

R H Fuchs. Photography as sculpture on Hamish Fulton. *Studio International,* Oct 1973, pp128–9.

B Reise. Hamish Fulton in the Stedelijk Museum, Amsterdam. *Studio International,* Dec 1973, pp226–7.

Hamish Fulton. Five knots for five days of walking, . . . Summer 1973. *Flash Art,* no52/53, Feb/Mar 1975, p27.

S Howe. Hamish Fulton at Sperone Westwater Fischer. *Art in America,* Mar/Apr 1976, pp106–7.

P Fuller. Hamish Fulton, ICA New Gallery. *Studio International,* May–June 1976, pp306–7.

M Bloem. Hamish Fulton . . . Stedelijk Van Abbemuseum in Eindhoven. *Museumjournaal,* Aug 1977, pp171–4. Dutch text.

L Rubinfien. Hamish Fulton, Museum of Modern Art, [New York]; Richard Long, Sperone Westwater Fischer Gallery. *Artforum,* Dec 1978, pp62–4.

M Auping. Hamish Fulton: moral landscapes. *Art in America,* Feb 1983, pp87–93.

R White. Hamish Fulton: interview . . . 1981. *View,* Spring 1983, pp1–28 (whole issue).

E Handy. Hamish Fulton: [John Weber]. *Arts Magazine,* Jan 1986, p135.

I Jeffrey. 'Campfire' by Hamish Fulton. *Creative Camera,* Mar 1986, pp37–7.

R C Morgan. Hamish Fulton: the residue of vision/the opening of mind. *Arts Magazine,* Mar 1986, pp86–9.

ANTONY GORMLEY

Solo Exhibitions

1981
Serpentine Gallery, London. *Two stones, by Antony Gormley.* Illus. dupl. typescript. 2pp. Organised by the Arts Council of Great Britain.
Whitechapel Art Gallery, London. *Antony Gormley: sculpture.* Illus. cat. [4]pp. Text by Jenni Lomax.

1983
Coracle Press, London.

1984
Riverside Studios, London. *Antony Gormley: new sculpture.* Dupl. typescript. 2pp. Travelling to Chapter, Cardiff. Also book published on the occasion of exhibition, *see* Bibliography.
Salvatore Ala Gallery, New York. *Antony Gormley.* Illus. book co-published by Coracle Press, London. Text by L Cooke.

1985
Galerie Wittenbrink, Munich.
Galleria Salvatore Ala, Milan.
Salvatore Ala Gallery, New York. *Drawings 1981–1985.* Book published on the occasion of the exhibition, *see* Bibliography,
Städtische Galerie, Regensburg, *Antony Gormley.* 71p. illus. cat. Text by S Nairne. Travelling to Frankfurt-am-Main.

1986
Salvatore Ala Gallery, New York.
Victoria Miro Gallery, London. *Drawings.*

1987
La Criee Halle d'Art Contemporain, Rennes. *Man made man.*
Galerie Hufkens de Lathuy, Brussels.
Salvatore Ala Gallery, New York. *Vehicle.*
Serpentine Gallery, London. *Antony Gormley: five works.* Illus. cat. 24pp. Text by the artist.
Siebu Contemporary Art Gallery, Tokyo. *Drawings.*

Bibliography

L Cooke. Anthony (sic) Gormley at the Whitechapel. *Artscribe,* no 29, 1981, pp56–7.

S Morgan. Antony Gormley, Whitechapel Gallery, (England, London). *Artforum,* Summer 1981, p101.

M Newman. Man's place: four works. *Art and Artists,* Oct 1982, pp35–7.

C Rowe. The Portland Clifftop sculpture project. *Aspects,* no 24, Oct 1983, p2.

L Cooke. *Antony Gormley.* New York: Salvatore Ala; [London: Coracle Press], 1984.

Antony Gormley. *Drawing from the mind's eye.* London: Journeyman Press, 1984. Published on the occasion of the Riverside Studios exhibition.

P Kopecek. Antony Gormley talking to Paul Kopecek. *Aspects,* no 25, Jan. 1984, pp4–5.

N Serota. Transformations – new sculpture from Britain. *Artefactum,* Feb/Mar. 1984, pp90–2.

M Archer. Antony Gormley: lead sculptures at the Coracle Press and Gallery. *Studio International,* no 1004, May 1984, p44.

C Collier. From the sublime to the ridiculous. *Studio International,* no 1007, 1984, p59.

P Kopecek. Anthony (sic) Gormley: [sculpture at Riverside Studios]. *Art Monthly,* Oct 1984, pp17–18.

C Ducann. Conversations with artists 2: interview with Antony Gormley. *World of Interiors,* Nov 1984, p210–11.

Antony Gormley. *Drawings.* Milan; New York: Salvatore Ala, 1985.

P Bickers. Antony Gormley: When is sculpture? Riverside Gallery, London. *Aspects,* no 29, p14–15.

R Pokorny. Using the body as if it was a face: summarizing an interview with Antony Gormley. *Neue Kunst in Europe,* no 9, July/Aug/Sept 1985, p10.

G L Bastos. Antony Gormley: a case. *Neue Kunst in Europe,* no 9, July/Aug/Sept, 1985, pp9–10.

V Conti. Antony Gormley: Milano . . . Regensburg . . . Frankfurt. *Artefactum,* Sept/Oct 1985, p48. French text.

J Fischer. Antony Gormley: Salvatore Ala. *Artforum,* Jan 1986, p86.

M Roustay. An interview with Antony Gormley. *Arts Magazine*, Sept 1987, pp21–5.

G Hughes. News: [Leeds station sculpture]. *Arts Review*, 24 Oct 1986, p560.

IAN HAMILTON FINLAY

Solo Exhibitions

1968
Axiom Gallery, London. [*Glass poems, stone poems, etc.*] Illus. card; dupl. typscrpt. 1pp.

1969
Pittencrieff House, Dunfermline. *'Concrete poetry' by Ian Hamilton Finlay*. Cat. 10pp.

1970
Bookshop Gallery, Sunderland. *Ian Hamilton Finlay*. Illus. folder with various inserts, incl. booklet with text by S. Bann.

1971
Winchester College of Art.

1972
Scottish National Gallery of Modern Art, Edinburgh. *Ian Hamilton Finlay: an illustrated essay*. Illus. cat. 52pp. Text by S Bann. Travelling to Stirling and Newcastle.

1974
National Maritime Museum, London.

1975
Max Planck Institute, Stuttgart. [*Environmental works*].

1976
Coracle Press, London. *Ian Hamilton Finlay: prints, cards, books, etc.*
Graeme Murray Gallery, Edinburgh. *Homage to Watteau.*
Southampton Art Gallery. *Ian Hamilton Finlay*. Folder, 8pp. Text by S Scobie

1977
Graeme Murray Gallery, Edinburgh.
Kettles Yard Gallery, Cambridge. *Ian Hamilton Finlay: collaborations. (Cambridge Poetry Festival, 1977)*. Illus. cat. 29pp.
Serpentine Gallery, London. *Ian Hamilton Finlay*. Illus. cat 96pp. Texts by S Bann, G Hincks and R Costley. Organised by the Arts Council.

1978
Scottish Arts Council, Edinburgh. [Artist withdraws prior to opening.]

1980
Collins Exhibition Hall, University of Strathclyde, Glasgow. *Nature over again after Poussin: some discovered landscapes*. Illus. artist's book, 30pp. Exhibition travelling throughout the U.K. and in Europe.

1980
Graeme Murray Gallery, Edinburgh. *Coincidence in the work of Ian Hamilton Finlay*. Illus. cat. 22pp. Texts by C McIntosh and the artist.

1981
Graeme Murray Gallery, Edinburgh. *Unnatural pebbles*. illus. artist's book.

1982
Chapelle Sainte Marie, Paris

1984
Graeme Murray Gallery, Edinburgh.
Merian Park, Basle. *Names on trees*. Artist's card.
Southampton Art Gallery. *Liberty, terror and virtue*. Catalogue published in *New Arcadians' Journal*, no 15, 1984. Texts by Y Abrioux, J Buckley and P Eyres.

1985
Bluecoat Gallery, Liverpool. *Liberty, terror and virtue*. With I Appleton and J Andrew. Dupl. typscrpt. 3pp.
Chapelle Sainte Marie, Paris. *Blinds*. Book published by Editions Lebeer Hossmann, Brussels. Text by A Harding.
Eric Fabre Gallery, Paris.

1986
Aberdeen Art Gallery. *Screenprints*. Dupl. typscrpt. 1pp.
Cistercian Abbey, L'Epau. [*Revolutionary aphorisms*]. Installations in Schweizergarten, Vienna; French Government Sculpture Park, Brittany; Van Abbemuseum, Eindhoven.
Victoria Miro Gallery, London.

1987
July–Aug Victoria Miro Gallery, London. *Homage to Ian Hamilton Finlay*. Illus. [57]pp. Text by Y. Abrioux.

Publications by the Artist

Publications by Ian Hamilton Finlay are too numerous to list here, but a thorough bibliography of them will be found in *Ian Hamilton Finlay: a visual primer*, by Y Abrioux (1985), *see* below.

Bibliography

R C Kenedy. Ian Hamilton Finlay. *Art International*, Mar 1973, pp37–9.

P Pacey. 'Those differing. . .marks'. Ian Hamilton Finlay and the Wild Hawthorn Press. *ARLIS Newsletter*, no 15, June 1973, pp31–4.

Two contemporary presses: The Wild Hawthorn Press and the Journeyman Press. London: Victoria & Albert Museum, 1974.

D Paterson, S Bann and B Lassus. *Selected ponds: photographs of the poets garden at Stonypath*. West Coast Poetry Review (Reno), 1976.

F Edeline. *Ian Hamilton Finlay*. Liège: Atelier de l'Agneau, 1977.

Ian Hamilton Finlay (with R. Costley and S. Bann). *Heroic emblems*. Calais (Vermont) : Z Press, 1977.

Ian Hamilton Finlay. Gardens at Dunsyre, Scotland. *Architectural Review*, Feb 1978, pp88–9.

S Bann. Finlay's Little Sparta. *Creative Camera*, Jan 1983, pp790–7.

Y Abrioux. Ian Hamilton Finlay: a visual primer; with introductory notes and commentaries by S. Bann. Edinburgh: Reaktion Books, 1985.

C Gintz. Neoclassical rearmament. *Art in America*, Feb 1987, pp110–17.

JOHN HILLIARD

Solo Exhibitions

1969
Camden Arts Cenrtre, London. *Recent work: John Hilliard*. Illus. folded card, 4pp. Text by J Hilliard.

1970
Lisson Gallery Warehouse, London. *A few photos: John Hilliard: luminescent installations and photographic works*. Folded illus. poster.
New Arts Lab, London. *Ian Breakwell and John Hilliard*. Duplicated illus. broadsheet; A4 illus. 1pp. Text by J Hilliard.

1971
Lisson Gallery, London.

1972
Nova Scotia College of Art and Design, Halifax.

1973
Lisson Gallery, London.

1974
Galleria Toselli, Milan.
Museum of Modern Art, Oxford. *Elemental conditioning*. Illus. artist's book, [34]pp.

1975
Galleria Banco, Brescia.
Lisson Gallery, London.

1976
Galerie Durand-Dessert, Paris.
Galerie Hetzler & Keller, Stuttgart.
Robert Self Gallery, Newcastle-upon-Tyne.

1977
Badischer Kunstverein, Karlsruhe. *Analytische Fotografie: Zweites Beispiel; John Hilliard: focus works 1975–76*. Illus. cat 20pp. Text by M. Schmalriede, J Hilliard.
Galerie Durand-Dessert, Paris.
Paul Maenz Gallery, Cologne.

1978
Galeria Akumulatory, Poznan.
Galleria Banco, Brescia.
John Gibson Gallery, New York.
Lisson Gallery, London. *John Hilliard: from the northern counties*. Illus. cat. 24pp. Text by J Hilliard. Travelling to Laing Art Gallery, Newcastle.
Studio Paola Betti, Milan.

1979
Galeria Foksal, Warsaw.
Galerie Durand-Dessert, Paris.
Ikon Gallery, Birmingham.

1980
Lisson Gallery, London.
Max Hetzler Gallery, Stuttgart.

1981
Galerie Durand-Dessert, Paris.
Orchard Gallery, Londonderry. *John Hilliard: Borderland: England/Scotland, USA, Canada*. Illus. artist's book, [24]pp.

1982
Amano Gallery, Osaka. *John Hilliard exhibition in Osaka and Kyoto*. 4pp. illus. folded card. Exhibition held concurrently at Ryo Gallery, Kyoto.

1983
Galerie Durand-Dessert, Paris.

1983–1984
Kölnischer Kunstverein, Cologne. *John Hilliard*. Illus. cat. [69]pp. Text by J Fisher, W Herzogenrath. Travelling to Bremen and Frankfurt.

1984
Galerie Média, Neuchâtel.
Institute of Contemporary Arts, London. *John Hilliard*. Illus. cat. [40]pp. Text by M Newman, J Hilliard.
Kettle's Yard Gallery, Cambridge. *John Hilliard: new works 1981 to 1983*. Illus. cat. [16]pp. Text by J Hilliard.

1985
Galerie Grita Insam, Vienna.

1986–1987
Provinciaal Museum, Hasselt. *John Hilliard*. Illus. cat. 58pp. Text by P Bonaventura.

1987
Galerie Durand-Dessert, Paris.
Sprengel Museum, Hanover.

1988
Bess Cutler Gallery, New York.

Publications by the Artist

See also 'Solo Exhibitions' for texts by the artist, or books published by him on the occasion of an exhibition.

Three pieces by John Hilliard. *Studio International*, Apr 1972, pp168–70.

Black depths, white expanse, grey extent and four other works, John Hilliard, 1974 and 1975. London: Robert Self, 1976. Illus. artist's book, [15]pp.

Unpopulated rural black-and-white exteriors, populated urban coloured interiors. *Aspects*, no 1, Oct–Dec 1977, 1pp.

Portfolio: John Hilliard. *British Journal of Photography*, 24 Feb. 1978, pp162–5.

John Hilliard: Triaden. *Kunstforum International*, no 33, 1979, pp160–9.

Charlie Hooker and Vincent Brown: a discussion. *Aspects*, no 11, Summer 1980, 3pp.

Drawing (in anticipation) of photographs. *Aspects*, no 16, Autumn 1981, 1pp.

John Hilliard (Northern Arts Fellow in the Visual Arts 1976–78): extracts from an exchange of letters between John Hilliard and Michael Newman. *Aspects*, no 29, Winter 1984–1985, p[4].

John Hilliard discussing his new works on canvas at the Institute of Contemporary Arts, London, 29 Nov 1984. *Audio Arts Magazine*, vol 7, no 3, 1985, side 2 (audio cassette).

Text of exhibition catalogue *Anthony Wilson: Satellite*, Riverside Studios, London, 1987.

Bibliography

John Hilliard and Ian Breakwell. *Studio International*, Sept 1970, pp94–5.

R Cork. From sculpture to photography: John Hilliard and the issue of self-awareness in medium use. *Studio International*, July–Aug 1975, pp60–8.

I Kirkwood. John Hilliard interviewed by Ian Kirkwood. *Art Log*, (Winchester School of Art), no 1, July 1978, pp3–10.

C Painter. John Hilliard: interview. *Aspects*, no 4, Autumn 1978, 2p.

P Dormer. John Hilliard. *Art Monthly*, Sept 1981, pp16–7.

R Durand. John Hilliard: scènes gelées pour des temps différents. *Art Press*, no 79, Mar 1984, pp11–3.

P Bonaventura. John Hilliard interviewed. *Artscribe*, no 50, Jan–Feb. 1985, pp22–4.

N Dimitrijevic. John Hilliard, ICA. *Flash Art*, Mar 1985, pp47–8.

Schiebung mit offenen Karten. *Art: das Kunstmagazin*, Sept 1986, pp62–70.

J Hoffmann. Fotografie digital: John Hilliard im Gesprach mit Justin Hoffmann. *Kunstforum International*, no 88, Apr 1987, pp262–6.

SHIRAZEH HOUSHIARY

Solo Exhibitions

1980
Chapter Arts Centre, Cardiff.

1982
Kettle's Yard Gallery, Cambridge.

1983
Centro d'Arte Contemporanea, Syracuse.
Grita Insam Gallery, Vienna.
Massimi Minimi Gallery, Milan.

1984
Lisson Gallery, London. *Shirazeh Houshiary*. 35pp. illus. cat. Text by L Cooke.

1986
Paul Andriesse Gallery, Amsterdam.

1987
Lisson Gallery, London. *Shirazeh Houshiary: Breath–recent sculpture*. 1pp. duplicated typescript.

Bibliography

M Newman. New sculpture in Britain. *Art in America*, Sept 1982, pp104–14, 177–9.

D Paparoni. Le radici della forma. *Tema Celeste*, no 1, Nov 1983, pp4–9.

L Rogozinski. Shirazeh Houshiary, Galleria Minimi. *Artforum*, Dec 1983, p91.

S Houshiary. Alba. *Tema Celeste*, no 2, Mar 1984, p19.

G Hughes. Shirazeh Houshiary. *Arts Review*, 26 Oct 1984, p529.

L Cooke. Shirazeh Houshiary. *Louisiana Revy*, Mar 1986, pp18–22. Danish text.

ANISH KAPOOR

Solo Exhibitions

1980
Galerie Patrice Alexandre, Paris.

1981
Coracle Press, London.

1982
Lisson Gallery, London.
Walker Art Gallery, Liverpool.

1983
Galerie 't Venster, Rotterdam. *Anish Kapoor*. Illus. cat 20pp. Text by M Newman.
Lisson Gallery, London.
Walker Art Gallery, Liverpool. *Anish Kapoor: feeling into form*. Illus. cat. 32pp. Text by M Livingstone.

1984
Barbara Gladstone Gallery, New York.

1985
Institute of Contemporary Art, Boston.
Kunsthalle, Basel. *Anish Kapoor*. Illus. cat. 43pp. Texts by J-C Ammann and A von Grevenstein.
Lisson Gallery, London. *Anish Kapoor: recent sculpture*.

1986
Albright-Knox Art Gallery, Buffalo. *Anish Kapoor*. Illus. cat. 8pp. Text by H. Raye.
Barbara Gladstone Gallery, New York.
Kunstnerness Hus, Oslo. *Anish Kapoor*. Illus. cat. 32pp. Text by L Cooke.
University Gallery, Amherst (Mass.). *Anish Kapoor: recent sculpture and drawings*. Illus. cat. 16pp. Text by H Posner.

Bibliography

C Collier. Anish Kapoor. *Arts Review*, 4 June 1982, pp289–90.

M Newman. Anish Kapoor. *Art Monthly*, no 58, July/Aug. 1982, p15.

M Newman. New sculpture in Britain. *Art in America*, Sept 1982, pp104–114, 177, 179.

W Feaver. Gas mask. *Art News*, Sept 1982, p123.

C Collier. Kapoor at the Lisson Gallery. *Studio International*, vol 196, no 1003, 1983, p51.

M Newman. Le drame du désir dans la sculpture d'Anish Kapoor. *Art Press*, no 70, May 1983, pp31–3.

P Groot. Anish Kapoor: 't Venster Gallery. *Flash Art*, May 1983, pp70–1.

M Newman. Figuren und Objekte: neue Skulptur in England. *Kunstforum* no 62, June 1983, pp22–35.

M R Beaumont. Anish Kapoor. *Arts Review*, Oct 1983, p622.

R Dutt. Anish Kapoor. *New Life*, no 346, Nov 1983.

D Paparoni. Le radici della forma. *Tema Celeste*, Nov 1983, pp4–9.

M Castello. Se il vero prende corpo. *Tema Celeste*, Nov 1983, pp12–15.

Sculptor Anish Kapoor. *Art Gallery*, Dec 1983/Jan 1984, p33.

K Baker. Anish Kapoor at Barbara Gladstone. *Art in America*, Oct 1984, pp189–90.

J Coleman. Anish Kapoor, Lisson Gallery. *Flash Art*, Jan 1984, p39.

M Newman. Discourse and desire: recent British sculpture. *Flash Art*, Jan 1984, pp48–55.

D Cameron. Anish Kapoor. *Arts Magazine*, Mar 1984, p4.

E Handy. Anish Kapoor. *Arts Magazine*, May 1984, p44.

N Princenthal. Anish Kapoor. *Art News*, Summer 1984, p189.

C Collier. Forms a hole can take . . .: Anish Kapoor, Lisson Gallery, London. *Studio International*, vol 198, no 1010, 1985, pp43–4.

D Paparoni. Spazio di Dio, Spazio della terra. *Tema Celeste*, no 6, 1985, pp46–9.

JOHN LATHAM

Solo Exhibitions, Performances, Events

1948
Kingley Gallery, London

1951
Kingley Gallery, London

1955
Obelisk Gallery, London

1957
Obelisk Gallery, London

1960
ICA, London
Galerie Schmela, Dusseldorf

1962
Galerie Internationale d'Art Moderne, Paris. Illus. cat.

1963
Bear Lane Gallery, Oxford
Kasmin Gallery, London *John Latham*, Illus. cat. Alan Gallery, New York

1964
Skoob Tower Ceremonies, Oxford, Bangor, London

1965
Bangor City Art Gallery, Wales

1966
Wordless Play, Mercury Theatre, London
Performances, Galerie Aachen and Galerie Schmela, Dusseldorf *Art and Culture*, Event at Portland Road, London

1970
Lisson Gallery, London

1972–73
The OHO-Project, 15 months continuous exhibition at Gallery House, London

1973
Big Breather, Imperial College, London

1974
Offer for Sale, The Gallery, London
One-Second Fictions, Art Net, London

1975
State of Mind, Kunsthalle Dusseldorf

1976
Work in Progress, Tate Gallery, London

1982
Riverside Studio, London
Apollohuis Gallery, Eindhoven

1983
Van Abbemuseum, Eindhoven

1987
John Latham, Early Works 1954–72, Lisson Gallery, London Illus. cat
Art & Culture 87, Josh Baer Gallery, New York

Bibliography

1955
Pierre Rouve: review of Obelisk Gallery exhibition in *Art News and Review*

1960
Lawrence Alloway: *New Decade Show*, ICA, January

1962
William Seitz: *Assemblage Exhibition*, Museum of Modern Art, New York.
Pierre Restany: *The New Realists*, Sidney Janis Gallery, New York

1963
Edward Lucie-Smith: Assemblages, review, Critics' Choice, *The Listener*, February 7

1966
Edward Lucie-Smith: *Pop Art*, book

1972
R Brooks: 'A Survey of the Avant-Garde in Britain, Gallery House', *London Public*, vol 2, Sept 12–30

1975
Jurgen Harten, R Brooks and John Stezaker: *State of Mind*, Kunsthalle, Dusseldorf.

1978
Peter Selz: book

1979
Rolf Sachse: article in *Kunstforum* (in German)

1982
Jean-Christophe Bailly: *Aleas Exhibition*, Musee d'Art Moderne, Paris

1984
John Latham, Michael Compton: *Report of a Surveyor*, Tate Gallery, London.
John Latham: 'Report of a Surveyor', *Journal of Art and Art Education*, No 5

1987
Tony Godfrey: 'John Latham: Early Works', *Art Monthly*, February
Michael Archer: 'John Latham, Lisson Gallery', *Artforum*, April
David Batchelor: 'John Latham, Lisson Gallery', *Artscribe*, May
John A Walker: 'John Latham and the book: the convergence of art and physics', *Burlington Magazine*, November

1988
Eleanor Heartney: 'John Latham at Josh Baer', *Art in America*, February

RICHARD LONG

Solo Exhibitions

1968
Konrad Fischer, Düsseldorf.

1969
John Gibson, New York.
Galleria Lambert, Milan.
Konrad Fischer, Düsseldorf.
Museum Haus Lange, Krefeld. Illus. cat.
Yvon Lambert, Paris.

1970
Dwan Gallery, New York *Richard Long*. 2 illus. cards.
Konrad Fischer, Düsseldorf.
Städtisches Museum Mönchengladbach. *Richard Long: Skulpturen*. Illus. cat.

1971
Gian Enzo Sperone, Turin.
Museum of Modern Art, Oxford.
Whitechapel Art Gallery, London. *Richard Long.*

1972
Museum of Modern Art, New York. *Projects*.
Yvon Lambert, Paris.

1973
Art & Project, Amsterdam. *Richard Long: Circle in the Andes*. Illus. artist's book, 4pp. *Art & Project Bulletin*, no 71.
Konrad Fischer, Düsseldorf.
Lisson Gallery, London.
Wide White Space, Antwerp.

1973–1974
Stedelijk Museum, Amsterdam. *Richard Long*. Illus. artist's book, 22pp. Cover title: *John Barleycorn.*

1974
John Weber, New York.
Lisson Gallery, London.
Scottish National Gallery of Modern Art, Edinburgh.
Richard Long: Inca Rock, Campfire Ash. Illus. artist's book, 27pp. Publ. London: Robert Self.

1975
Art & Project, Amsterdam. *West Coast of Ireland: Richard Long 1975*. Illus. artist's book, 4pp. *Art & Project Bulletin*, no 90.
Konrad Fischer, Düsseldorf.
Plymouth School of Art.
Rolf Preisig, Basle.
Wide White Space, Antwerp.
Yvon Lambert, Paris.

1976
Arnolfini Gallery, Bristol.
Art Agency, Tokyo.
Art & Project, Amsterdam. *A line in the Himalayas: Richard Long*. 4p. illus. artist's book. *Art & Project Bulletin*, no 99.
Gian Enzo Sperone, Rome.
Konrad Fischer, Düsseldorf.
Lisson Gallery, London.
Sperone Westwater, Fischer, New York.
Venice Biennale, British Pavilion. *Some notes on the work of Richard Long*. Illus. cat. [20]pp. Text by M Compton.
Wide White Space, Antwerp.

1977
Art & Project, Amsterdam.
Art Gallery of New South Wales, Sydney.
Gallery Akumulatory, Poznan.
Kunsthalle Berne. *A hundred stones: one mile between first and last: Richard Long, Cornwall, England, 1977*. Illus. artist's book, [100]pp.

Lisson Gallery, London.
National Gallery of Victoria, Melbourne.
Rolf Preisig, Basle.
Whitechapel Art Gallery, London. *The North Woods: Richard Long*. Illus. artist's book [16]pp.; typscrpt list of works.

1978
Art & Project, Amsterdam.
Ausstellungsraum Ulrich Ruckriem, Hamburg.
Konrad Fischer, Düsseldorf.
Lisson Gallery, London. *Richard Long: Outback*.
Park Square Gallery, Leeds.
Sperone Westwater Fischer, New York.
Yvon Lambert, Paris.

1979
Anthony d'Offay, London. *Richard Long: the River Avon*. 4pp. illus. folded card; dupl. typscrpt. 1pp.
Art Agency, Tokyo.
InK, Zurich.
Lisson Gallery, London.
Museum of Modern Art, Oxford.
Orchard Gallery, Londonderry.
Photographic Gallery, Southampton University.
Rolf Preisig, Basle.
Stedelijk van Abbemuseum, Eindhoven. *Richard Long*. Illus. artist's book, [136]pp.

1980
Anthony d'Offay, London. *Richard Long: new work*. 1pp. duplicated typscrpt.
Art & Project, Amsterdam. *Watermarks–pouring water on a river bed, the Sierra Madre, Mexico 1979; Richard Long: stones and sticks*. Illus. artist's book, 4pp. *Art & Project Bulletin*, no 116.
Fogg Art Museum, Cambridge (Mass.). *Richard Long*. Illus. cat. 12pp. Text by G Jepson.
Karen and Jean Bernier, Athens.
Konrad Fischer, Düsseldorf.
Sperone Westwater Fischer, New York.

1981
Anthony d'Offay, London. *Richard Long*. Dupl. typscrpt. 3pp.
David Bellman, Toronto.
Graeme Murray, Edinburgh.
Konrad Fischer, Düsseldorf.
Sperone Westwater Fischer, New York.

1981–82
CAPC, Musée d'Art Contemporain de Bordeaux. *Richard Long: Bordeaux 1981*. Illus. cat. [23]pp.

1982
Art & Project, Amsterdam. *A line in Scotland 1981: Richard Long*. Illus. artist's book, 4pp. *Art & Project Bulletin*, no 128.
Flow Ace Gallery, Los Angeles.
Sperone Westwater Fischer, New York.
Yvon Lambert, Paris.

1983
Anthony d'Offay, London. *Richard Long: new works*. Dupl. typescript. 1pp.

1982–1983
National Gallery of Canada, Ottawa. *Selected works: oeuvres choisies, 1979–1982: Richard Long*. Illus. artist's book, [24]pp. Also illus, folded sheet, [14]pp. Text by J Bradley.

1983
Arnolfini Gallery, Bristol. *Touchstones*. Illus. artist's book, [24]pp. Text by M Craig-Martin, R Long.
Art Agency, Tokyo.
Art & Project, Amsterdam. *Brushed path, a line in Nepal: Richard Long 1983*. Illus. artist's book, 4pp. *Art & Project Bulletin*, no 135.
Century Cultural Centre, Tokyo.
David Bellman Gallery, Toronto. *Richard Long: Canadian sculptures*. Illus. card, 2pp.
Galleria Tucci Russo, Turin. *Fango, pietre, legni: Richard Long*. Illus. artist's book, [16]pp.
Konrad Fischer, Düsseldorf.

1984
Anthony d'Offay, London. *Sixteen works: Richard Long*. Illus. artist's book, [38]pp.
Butler Gallery, Kilkenny Castle, Kilkenny.
Century Cultural Foundation, Tokyo. *[Richard Long] 1984*. Illus. artist's book, [36]pp.
Coracle Press, London.
Dallas Museum of Art. *Concentrations 9: Richard Long*. Illus. folded card, [6]pp. Text by S Graze, R Long.
Galerie Crousel-Hussenot, Paris.
Jean Bernier, Athens.
Konrad Fischer, Düsseldorf.
Lucio Amelio, Naples.
Orchard Gallery, Londonderry. *River Avon mud works: Richard Long*. Illus. folded card 8pp. Artist's book.
Sperone Westwater, New York.

1985
Abbot Hall Art Gallery, Kendal. *Richard Long*. Folded card, 4pp.
Anthony d'Offay, London. *Richard Long: from pass to pass–Sniougoutse La*. Dupl. typscrpt. 1pp.
Galerie Buchmann, Basle. *Richard Long und die Nähe der Dinge*. Illus. cat. 43pp. Text by A. Wildermuth.
Malmö Konsthall.
Padiglione d'Arte Contemporanea, Milan. *Il luogo buono*.

1986
Anthony d'Offay, London.
Antonio Tucci Russo, Turin.

Galerie Crousel-Hussenot, Paris.
Palacio de Cristal, Madrid. Richard Long: piedras. Illus. cat. [57]pp. Text by A Seymour, R Long.
Solomon R. Guggenheim Museum. New York. *Richard Long*. Illus. cat. 237pp. Text by R H Fuchs.
Sperone Westwater, New York.

1987
Cairn Gallery, Nailsworth (Glos).
Centre National d'Art Contemporain de Grenoble.
Coracle Atlantic Foundation, Renshaw Hall, Liverpool.
Donald Young Gallery, Chicago. *Out of the wind*.
Musée Rath, Geneva. *Stone water miles: Richard Long*. Illus. artist's book, [80]pp. Text by H Teicher.
Porin Taidmuseo, Pori. *Richard Long: Special installation*.

Publications by the Artist

Some books published on the occasion of exhibitions, appear under 'Solo Exhibitions'.

Reflection in the Little Pigeon River, Great Smoky Mountain, Tennessee. Amsterdam: Art & Project, 1970. Artist's book. *Art & Project Bulletin*, no 35.

Studio International [19 stills from the work of Richard Long], Mar 1970, pp106–11.

From along a riverbank. . Amsterdam: Art & Project, 1971. Illus. artist's book, 20pp.

Two sheepdogs cross in and out of the passing shadows, the clouds drift over the hill with a storm. London: Lisson Publications, 1971. Illus. artist's book, 12pp.

South America 1972. Düsseldorf: Konrad Fischer, 1972. Illus. artist's book, 32pp.

From around a lake. Amsterdam: Art & Project, 1973. Illus. artist's book, 20pp.

Sydamerika 1972. Ahus, Kalejdoskop, 1973. Illus. artist's book, 33pp.

A straight hundred mile walk in Australia. Sydney: John Kaldor, Project 6, 1977.

Rivers and stones. Newlyn, Newlyn Orion Galleries, 1978. Illus. artists book, [16]pp. on the occasion of exhibition of Peter Joseph, Richard Long and David Tremlett at Newlyn Art Gallery, Penzance, 1978.

Aggie Weston's, no 16, Winter 1979, London: Coracle Press, 1979. Whole issue in form of illus. artist's book.

River Avon book. (London: Anthony d'Offay, 1979.) Artist's book, [64]pp.

Five, six, pick up sticks, seven eight, lay them straight. London: Anthony d'Offay, 1980. Folded card, [6]pp. Artist's book.

A walk past standing stones: a day's walk past the standing stones of Penwith Peninsula. London: Coracle Press for Anthony d'Offay, 1980. Illus. folded leaf. [10]pp. Artist's book.

Twelve works 1979–1981. London: Coracle Press for Anthony d'Offay, 1981. Artist's book, [28]pp.

Mexico 1979. Eindhoven: Stedelijk van Abbemuseum, 1982. Illus. artist's book, [24]pp.

Countless stones: a 21 day footpath walk, Central Nepal, 1983, views looking forward, in sequence. Eindhoven, Stedelijk Van Abbemuseum; Openbaar Kunstbezit, 1983. Illus. artist's book, ca. 100pp.

Planes of vision. Aachen: Ottenhausen Verlag; Kassel: Gesamtherstellung Bärenreiter, 1983. Artist's book, [100]pp.

Richard Long replies to a critic. Art Monthly, July–Aug. 1983, pp20–21.

Mud hand prints. London: Coracle Press, 1984. Artist's book, [8]pp.

Postcard 1968–1982. Bordeaux: Musée d'Art Contemporain, 1984.

Muddy Water marks. Noordwijk: M W Press, 1985. Illus. artist's book, [32]pp.

Richard Long. [Bordeaux] Fonds Régional d'Art Contemporain, Aquitaine, 1985. Illus. artist's book, [16]pp.

Richard Long in conversation: Bristol 19.11.1985. [Noordwijk] Holland: M W Press, 1985.

Lines of time. Amsterdam: Stichting Edy de Wilde-Lezing, 1986.

Bibliography

G Glueck. Richard Long. *Art in America*, Sept–Oct 1970, pp41.

K Honnef. Richard Long. *Kunstwerk*, Oct–Nov 1970, pp69–70.

C Harrison. Richard Long at the Whitechapel. . . *Studio International*, Jan 1972, pp33–4.

G Celant. Richard Long. *Domus*, no 511, June 1972, pp48–50.

S Field. Touching the earth. *Art and Artists*, Apr 1973, pp15–9.

J Morschel. Richard Long. *Kunstwerk*, Mar 1974, p40.

R H Fuchs. Memories of passing: a note on Richard Long. *Studio International*, Apr 1974, pp172–3.

A-S Wooster. Richard Long at Weber. *Art in America*, July–Aug 1974, pp83–4.

S Wilson. Richard Long at the Scottish National Gallery of Modern Art. *Studio International*, Sept 1974, review pp12–3.

H Adams. Jan Dibbets and Richard Long. *Studio International*, Jan 1977, pp66–8.

Richard Long. *Kalejdoskop*, no 3, 1978, whole issue. Swedish text.

B Marcelis. Richard Long: beauté et ambiguité du land art. *Domus*, no 601, Dec 1979, pp48–9.

N Foote. Long walks. *Artforum*, Summer 1980, pp42–7.

M Craig-Martin. London: Richard Long at Anthony d'Offay. *Burlington Magazine*, Nov 1980, pp791–2.

J Fisher. Richard Long. *Aspects*, no 14, Spring 1981, 1p.

J-M Poinsot. Richard Long: construire le paysage. *Art Press*, no 53, Nov 1981, pp9–11.

J T Paoletti. Richard Long. *Arts Magazine*, Dec 1982, p3.

H Duffy. Richard Long at the National Gallery of Canada. *Artmagazine*, Spring 1983, pp32–3.

L Biggs. Richard Long. *Arnolfini Review*, Apr 1983, pp1–2.

L Cooke. Richard Long. *Art Monthly*, May 1983, pp8–10.

R Cranshaw and A. Lewis. Richard Long at Arnolfini and Anthony d'Offay. *Artscribe*, no 41, June 1983, pp54–6.

J Coleman. Richard Long. *Studio International*, vol 196, no 100, July 1983, p10.

N Stewart. Richard Long: lines of thought: a conversation. *Circa*, Nov–Dec 1984, pp8–13.

G Gintz. Richard Long: la vision, le paysage, le temps. *Art Press*, no 104, June 1986, pp4–8.

R Bevan. Richard Long: two recent commissions, *Burlington Magazine*, Oct 1986, pp743–5.

M Poirier. Richard Long: the landscape as canvas. *Art News*, Dec 1986, p151.

S Morgan. Paths and circles: Richard Long, Solomon R. Guggenheim Museum. *C Magazine*, no 12, 1987, pp34–5.

BRUCE McLEAN

Solo Exhibitions and Performances

1965
St Martin's School of Art, London. *Mary waving goodbye to the train.* (Performance).

1969
Konrad Fischer, Düsseldorf.
St Martin's School of Art; Royal College of Art; Hanover Gallery, London. *Interview sculpture with Gilbert & George.*

1970
Nova Scotia College of Art Gallery, Halifax. *King for a day.*

1971
Situation, London. *Objects no concepts.*
Situation, London. *There's a sculpture on my shoulder.* (Performance).
Yvon Lambert, Paris.

1972
Arthur Tooth, London. *Critic's choice* (Performance with Nice Style and Peter Lacoux).
Françoise Lambert, Milan.
Hanover Grand, London. *Deep freeze.* (Performance plus press conference with Nice Style).
Royal College of Art, London. *Semi domestic poses; Modern posture and stance moulds.* (Performance with Nice Style).

Sonia Henie-Niels Onstad Foundation, Oslo. *Grab it while you can* in *British thing.* (Performance with Nice Style).
Tate Gallery, London. *King for a day.* Book published on the occasion of the exhibition, *see* Publications by the Artist.

1974
Architectural Association, London. *A problem of positioning.* (Performance with Nice Style).
Garage, London. *High up on a Baroque palazzo. (Performance with Nice Style).*

1975
Morton's Restaurant, London. *Final pose piece.* (Performance with Nice Style).
Museum of Modern Art, Oxford. *Early works 1967–1975.* Illus. card; Dupl. illus. typscrpt. 2pp.
Museum of Modern Art, Oxford. *Objects no concepts.*
P M J Self, London. *Nice Style: the end of an era 1971–1975.* (Performance with Nice Style).
Robert Self, London. *Concept/comic* (Interview).
Robert Self, Newcastle upon Tyne.

1977
Battersea Arts Centre, London. *Sorry! a minimal musical in parts. Part 3, Trying for grey.* (Performance with Sylvia Ziranek).
Robert Self, London and Newcastle. *New political drawings.*
Serpentine Gallery, London. *In terms of, an institutional farce sculpture.*

1978
The Kitchen, New York. *The object of the exercise?* (Performance with Rosy McLean).

1979
Barry Barker Gallery, London.
Riverside Studios, London. *The masterwork/award-winning fishknife.* Illus. artist's book, [10]pp, published by Hammersmith Riverside Arts Trust, 1979. Performance with Paul Richard.
Southampton Performance Festival. *Action at a distance* (Performance with Peter Lacoux, Rosy McLean and Sylvia Ziranek).
University Gallery, Southampton.

1980
Fruitmarket Gallery, Edinburgh. *Actions at a distance, Questions of misinterpretation.*
Mickery Theatre, Amsterdam. *High up on a Baroque palazzo* (Performance).
Riverside Studios, London. *Possibly nude by a coal bunker* (Performance).
Third Eye Centre, Glasgow. *New works and performances/actions positions.* Illus. cat. 36pp. Texts by D Brown, S Kent. Travelling to Edinburgh and Bristol.
Third Eye Centre, Glasgow. *A thin brimm* (Performance).

1981
Anthony d'Offay Gallery, London.
Art & Project, Amsterdam. *Bruce McLean.* Catalogue published as *Art & Project Bulletin*, no 124.
Chantal Crousel, Paris.
Kunsthalle, Basle. *Bruce McLean: [works 1967–1980].* Illus. cat. 64pp; supplement, 27pp. Text by N Dimitrejevic. Travelling to London and Eindhoven.
Kunsthalle, Basle. *A contemporary dance* (Performance).
Musée d'Art et d'Industrie, Saint-Etienne. *Bruce McLean.* Illus. cat. 28pp. Text by N Dimitrijevic.

1982
Anthony d'Offay, London. *Painting on the angst* (Performance).
Chantal Crousel, Paris.
Grita Insam, Vienna.
Kanrasha Gallery, Tokyo.
Mary Boone Gallery, New York.
Modern Art Galerie, Vienna.
Museum Folkwang, Essen. *Une danse contemporaine* (Performance).
Riverside Studios. London. *Farewell performance* (Performance).

1983
DAAD-Galerie, Berlin. *Bruce McLean: Berlin/London.*
Dany Keller, Munich. *Bruce McLean: London.* Illus. cat. [12]pp.
Institute of Contemporary Arts, London.
Kanrasha Gallery, Tokyo.
Kiki Maier-Hahn, Düsseldorf.
Riverside Studios, London. *Another bad turn-up.* (Performance).
Van Abbemuseum, Eindhoven.
Whitechapel Art Gallery, London. *Bruce McLean: Berlin/London.* Book co-published with DAAD-Galerie Berlin on the occasion of the exhibition.

1984
Art Palace, New York. *Bruce McLean.* Illus. cat. [20]pp. Text by M Amaya.
Badischer Kunstverein, Karlsruhe. *Bruce McLean.* Illus. cat. [46]pp. Text by A Vowinckel.
Bernard Jacobson Gallery, New York.
Galerie Fahnemann, Berlin. *Bruce McLean.* Illus. cat [28]pp. Text by M Gooding.
Galerie Dany Keller, Munich.

1984
Galleria Fina Bitterlin, Florence. *Bruce McLean: Firenze.* Illus. cat. 27pp. Text by J-C Ammann.
Kanrasha Gallery, Tokyo.

1985
Anthony d'Offay, London.
Bernard Jacobson, London.
Galerie Gmyrek, Düsseldorf. *Bruce McLean: Simple manners or physical violence – neue Bilder.* Illus. cat. 58pp. Text by N Rosenthal, U Krempel.
KunstAkademie, Düsseldorf. *Simple manners or physical violence* (Performance).
Riverside Studios, London. *The Audio Arts Award.* (Performance).
Riverside Studios, London. *Simple manners or physical violence* (Performance).
Tate Gallery, London. *Bruce McLean.* Illus. folded card, 6pp. Text by R Francis.
Tate Gallery, London. *Simple manners or physical violence* (Performance).

1986
Anthony d'Offay Gallery, London.
Bernard Jacobson Gallery, London.
Fruitmarket Gallery, Edinburgh. *Partitions* (Performance).
Laing Art Gallery, Newcastle upon Tyne. *Physical manners and good violence* (Performance).
Scottish Gallery, Edinburgh. *Bruce McLean: exhibition of paintings, marks on paper, ceramics, prints and drawings; Dance-performance 'Partitions'.* Illus. cat. [24]pp. text by M R Beaumont.

Tate Gallery, Liverpool. *Events Summer 1986:. . . Bruce McLean, David Ward: a new performance.* Illus. cat. 32pp. Text by R Francis.
Tate Gallery, Liverpool. *A song for the North* (Performance).

1987
Anthony d'Offay Gallery, London. *Bruce McLean provides a 'guide' to his exhibition, The floor, the wall, the fireplace, at the Anthony d'Offay Gallery.* in *Audio Arts*, vol 8, nos 2/3, tape 1, side 2.
Galerie Fahnemann, Berlin.
Hillman Holland, Atlanta.

Publications by the Artist

See also some publications connected with Solo Exhibitions and Performances.

Not even crimble crumble. *Studio International*, Oct 1970, pp156–9.

Their grassy places, 1969; An evergreen memory, 1969. *Studio International*, May 1971, pp206–7.

Retrospective: king for a day and 999 other pieces, works, things, etc, 1969. London: Situation Publications, 1972. Illus. artist's book on occasion of the exhibition, [56]pp.

Nice Style at the Hanover Grand, December 1973. *Audio Arts*, vol 1, no 2, 1974, side 2 (audio cassette).

Nice Style at Garage. *Audio Arts*, Supplement 1974, whole issue (audio cassette).

B McLean with S Ziranek. Sorry: a minimal musical in parts. *Audio Arts*, Supplement 1977, whole issue (audio cassette).

Mackerel and mandolins. *Aspects*, no 4, Autumn, 1978, 1p.

B McLean and P. Richards. 'The masterwork' award winning fish-knife. *Audio Arts*, Supplement 1979, whole issue (audio cassette).
Drawing. *Aspects*, no 16, Autumn 1981, 1p.

Dream works; text by M Gooding. London; Berlin: Knife Edge Press, 1985. Illus. artist's book, [58]pp.

Ladder; text by M Gooding. London: Knife Edge Press, 1986. Illus. artist's book, [34]pp.

Home manoeuvres. London: Knife Edge Press, 1987.

Bibliography

M Hartney. Nice Style at Garage. *Studio International*, Nov 1974, review pp9–10.

M Chaimowicz. Furlong/McLean: Academic Board. *Studio International*, Mar–Apr 1977, pp137–8.

J McEwen. A Letter from London. *Artscanada*, Oct–Nov 1977, p44.

N Dimitrijevic. Pose performance of Bruce McLean. *Art Monthly*, no 24, Mar 1979, pp5–7.

J Roberts. Bruce McLean and Cosey Fanni Tutti at the Hayward Annual 79. *PS*, no 2, Sept–Oct 1979, p19.

S Wedderburn. Masterwork. *PS*, no 3, Nov–Dec 1979, pp8–9.

A Pohlen. Basel: Bruce McLean, Kunsthalle. *Artforum*, Nov 1981, p92.

J Roberts. Bruce McLean. *Artscribe*, no 32, Dec 1981, pp66–7.

N Dimitrijevic. Bruce McLean, Anthony d'Offay. *Flash Art*, Dec 1981–Jan 1982, p53.

A J Reynolds. Bruce McLean. *Studio International*, vol 196, no 999, Apr–May 1983, pp36–7.

M Collings. Bruce McLean performance at Riverside. *Artscribe*, no 41, June 1983, pp47–8.

D Petherbridge. Poses and overposes. *Architectural Review*, Sept 1983, pp59–61.

S Morgan. Bruce McLean, ICA, Whitechapel Gallery, Riverside Studios. *Artforum*, Oct 1983, pp83–4.

M Amaya. McLeaning up the act. *Studio International*, vol 197, no 1006, 1984, pp26–9.

L Zelevansky. Bruce McLean, Art Palace. *Art News*, Jan 1985, p151.

M Gooding. McLean's pots. *Crafts*, May–June 1986, pp16–21.

Bruce McLean: 'a brush with politics'. *Artics*, no 4, June–Aug 1986, pp43–8.

WILLIAM TUCKER

Solo Exhibitions

1962
Grabowski Gallery, London. *Michael Kidner: paintings; William Tucker: sculpture.* Illus. cat. [12]pp.

1963
Rowan Gallery, London. *William Tucker.* Illus. cat. [8]pp. Text by C Salvesen.

1965
Richard Feigen Gallery, New York.

1966
Rowan Gallery, London. *William Tucker: new sculpture.* Illus. cat. 4pp.

1967
Kasmin Limited, London. *William Tucker: three sculptures.* Illus. card.

1968
Elkon Gallery, New York.

1969
Kasmin Limited, London. *William Tucker: recent work.* Illus. cat. 4pp.
Leeds City Art Gallery. Gregory Fellow exhibition.
Leslie Waddington Prints, London. *William Tucker: exhibition of collaged screenprints.* Illus. folded card, 2pp.

1970
Kasmin Limited, London. *William Tucker: new sculpture.* Illus. card.

1972
Venice Biennale, British Pavilion. *William Tucker.* Illus. cat. [12]pp. Text by A Forge.

1973
Kunstverein, Hamburg.
Leslie Waddington, London.
Serpentine Gallery, London. *William Tucker: sculpture
1970–73.* Illus. cat. 56pp. Text by A Forge. Organised by
Arts Council of Great Britain.
Waddington Galleries II, London. *William Tucker: sculptures.* Illus. folded card, 4pp.

1974
Hester van Royen Gallery, London. *William Tucker:
drawings.* Illus. cat. [8]pp. Text by B Martin.

1976
Galerie Wintersberger, Cologne.
Wakefield Art Gallery. Drawings.

1977
Fruitmarket Gallery, Edinburgh. *William Tucker: sculptures.* Illus. cat. 26pp. Text by N Lynton. Organised by
Arts council of Great Britain. Travelling throughout
Britain 1977–1978.
Robert Elkon Gallery, New York.

1978
Sable–Castelli Gallery, Toronto.

1979
Robert Elkon Gallery, New York.

1980
David Reids Gallery, Sydney.
Powell St. Gallery, Melbourne.
Robert Elkon Gallery, New York.

1981
L'Isola, Rome. *William Tucker.* Illus. cat. [24]pp.

1982
Bernard Jacobson Gallery, Los Angeles.
Robert Elkon Gallery, New York. *William Tucker:
sculpture and drawings.* Illus. cat. [12]pp.

1984
David McKee Gallery, New York. *William Tucker: new
work.*
L'Isola, Rome. *William Tucker.* Illus. cat [31]pp. Text by
C Battaglia.

1985
Chicago International Art Fair. *William Tucker.*
David McKee Gallery, New York. *William Tucker:
gymnasts.*
Neuberger Museum, Purchase (N Y). *William Tucker:
three gymnasts.*
Pamela Auchincloss Gallery, Santa Barbara. *William
Tucker: sculpture and drawing.*

1987
Annely Juda Fine Art, London. *William Tucker: recent
sculptures and monotypes.* Illus. cat. [15]pp.; Dupl. typscrpt
3pp. Text by W Tucker.
Padiglione d'Arte Contemporanea, Milan.
Pamela Auchincloss Gallery, Santa Barbara. *William
Tucker: bronzes.*
Tate Gallery, London. *William Tucker: Gods: five recent
sculptures.* Illus. cat. 23pp. Text by D Ashton.

1987–1988
L'Isola, Rome. *William Tucker: horses.* Illus. cat. [24]pp.
Text by 1988 W Tucker.

Bibliography

J Burr. Structures in space. *Apollo*, Oct 1973, p306.

B Martin. William Tucker. *Studio International*, Oct 1973,
pp150–1.

P Fuller. London. *Art and Artists*, May 1975, pp34–5.

E F Fry. 'Early modern sculpture' [by] William Tucker.
Artforum, Summer 1975, pp63–4.

L Alloway. Caro's art – Tucker's choice. *Artforum*, Oct
1975, pp65–71.

D. Ashton. William Tucker: 'Early modern sculpture'.
Art Bulletin, Dec 1975, pp599–60.

A. Elsen. A review of William Tucker's 'Early modern
sculpture'. . . *Art Journal*, Winter 1975–76, pp136–8.

William Tucker interviewed by Caryn Faure Walker and
Ben Jones. *Artscribe*, no 3, Summer 1976, pp2–3.

K Baker. William Tucker: meaning vs. matter. *Art in
America*, Nov–Dec 1977, pp102–3.

R. Shuebrook, William Tucker at the Sable-Castelli
Gallery. *Artmagazine*, June 1978, p74.

R Berlind. William Tucker at Elkon. *Art in America*, Oct
1979, p122.

D Ashton. William Tucker's gyre. *Arts Magazine*, June
1979, pp128–9.

R Shuebrook. William Tucker. *Artscribe*, no. 36, Aug.
1982, pp35–43.

M Megged. The sculpture of William Tucker. *Arts
Magazine*, Sept 1982, pp104–5.

K Baker. William Tucker at David McKee. *Art in
America*, Oct 1984, p204.

Publications by the Artist

Looking at Picasso's sculptures. *Studio International*, July–
Aug 1967, p6.

Moore at the Tate. *Studio International*, Oct 1968, p124.

The sculpture of Matisse, in exhibition catalogue *Henri
Matisse 1869–1954 sculpture.* Victor Waddington, London,
1969. 9pp.

An essay on sculpture. *Studio International*, Jan 1969,
pp12–3.

W Tucker et al. Anthony Caro's works; a symposium by
four sculptors. *Studio International*, Jan 1969, pp14–20.

Sydney Nolan and William Tucker discuss their recent
work. *Studio International*, June 1969, pp297–8, 303.

The sculpture of Matisse. *Studio International*, July–Aug
1969, pp25–7.

The sculpture of Gonzalez. *Studio International*, Dec 1970,
pp236–9.

Studio International, [Henri Laurens. Exhibition at the
Hayward.] July 1971, pp24–5.

Notes on sculpture, public sculpture and patronage.
Studio International, Jan 1972, p9.

A note on Rietveld as a sculptor. *Studio International*, Apr
1972, p176.

Sculpture and architecture: an introduction to my recent
work. *Studio International*, June 1972, pp241–3.

Pro-Stuyvesant. *Studio International*, Dec 1972, pp215–6.

The language of sculpture. London: Thames and Hudson,
1974. US edition has title *Early modern sculpture.*

What sculpture is. *Studio International*, Dec. 1974.
pp232–3. Continued in issues for Jan–Feb 1975, pp16–8,
Mar–Apr. 1975, pp120–3, May–June 1975, pp188–90.

The condition of sculpture. *Studio International*, May–June
1975, pp186–7. Text of introduction to catalogue of
exhibition held Hayward Gallery, organised by Arts
Council of Great Britain.

Matisse's sculpture: the grasped and the seen. *Art in
America*, July 1975, pp62–6.

Space, illusion, sculpture. *Tracks*, vol 1, no 3, Fall 1975,
pp5–27.

The road to Tirgu Jiu. *Art in America*, Nov–Dec 1976,
pp96–101.

Modernism, freedom, sculpture. *Art Journal*, Winter
1977–78. pp153–6.

The image as emblem. *Art in America*, Jan 1981, pp107–8.

The Gonzalez exhibition. *New Criterion*, May 1983.

RICHARD WENTWORTH

Solo Exhibitions

1973
Greenwich Theatre Gallery, London. *Various drawings.*

1974
Art Net, London. *Instalment.*

1974–1975
Felicity Samuel Gallery, London. *Richard Wentworth.*
Dupl. typscrpt. 3pp.; illus. card.

1984
Lisson Gallery, London. *Richard Wentworth.* Illus. cat.
32pp. Text by L Cooke. Interview with R Wentworth.
Tate Gallery, London. *Richard Wentworth: making do and
getting by.* Illus. cat. 2pp. Text by R Wentworth.

1986
Lisson Gallery, London. *Richard Wentworth: sculptures.*
Illus. cat. 48 pp. Text by I Jeffrey.
Riverside Studios, London. *Richard Wentworth: sculpture.*
56pp. Text by G Hilty.

Bibliography

F Crichton. London Letter. *Art International*, Feb 1975,
p36.

F Crichton. Richard Wentworth at Art Net. . . and at the
Felicity Samuel Gallery. *Studio International*, Jan–Feb
1975, review
pp 9–10.

R Wentworth. Making do and getting by. Artscribe, no 14, Oct 1978, pp21–3.

W Feaver. Bashing on regardless. *Art News*, Oct 1984, pp170–1.

S Morgan. Richard Wentworth's ad hoc esthetics. *Artforum*, Apr 1985, pp64–6.

L Cooke. Godt Nok. *Louisiana Revy*, Mar 1986, pp38–41. Danish text.

L Berryman. Richard Wentworth. *Arts Review*, 4 July 1986, p377.

S Morgan. Richard Wentworth, Lisson Gallery. *Artforum*, Sept 86, p146.

ALISON WILDING

Solo Exhibitions

1973
Central School of Art, London. *Alison Wilding.*

1976
AIR Gallery, London. *Alison Wilding.* Broadsheet.

1979
45 Tabernacle Street, London. *Alison Wilding.*

1982
Kettles Yard, Cambridge. *Alison Wilding sculpture.* Illus. card.

1983
Salvatore Ala Gallery, New York. *Alison Wilding.* Illus. card.

1985
Salvatore Ala Gallery, New York. *Alison Wilding.* Illus. card.
Serpentine Gallery, London. *Alison Wilding.* Illus. cat. 32pp. Text by L Cooke. Organised by the Arts Council of Great Britain.

1986
Richard Salmon at Studio 4, London. *Alison Wilding.* Dupl. typscrpt. 5pp.
Richard Salmon at Studio 4, London. *New sculpture by Alison Wilding.* Illus. card; dupl. typscrpt 1p.
Salvatore Ala Gallery, New York. *Alison Wilding.* Illus. card.

1987
Galleri Lång, Malmö. *Alison Wilding.*
Karsten Schubert, London. *Alison Wilding: sculptures.* Illus. cat. 29pp. Text by G Watson.
Richard Salmon Ltd, London. *Alison Wilding into the brass.* Illus. card.

1987–1988
Museum of Modern Art, New York. *Projects.*

Bibliography

K Baker. Alison Wilding at Salvatore Ala. *Art in America*, Mar 1984, p163.

R Clark. Precarious poise. *The Listener*, 25 Apr 1985.

N Dimitrijevic. Alison Wilding at the Serpentine. *Flash Art*, no 123, Summer 1985, pp58–9.

M Kaufmann. Alison Wilding. *Flash Art* [Italian ed], no 129, Nov 1985.

L Cooke. Alison Wilding: sailing on. *Artscribe*, Apr/May 1986, pp46–7.

J Silverthorne. Alison Wilding: Salvatore Ala. *Artforum*, Summer 1986, p122.

B Maestri. Milan: Alison Wilding. *Artforum*, Feb 1986, p114.

L Cooke. Alison Wilding. *Louisiana Revy*, Mar 1986, pp42–5. Danish text.

R Cook. Making space. *The Listener*, 7 May 1987, pp32–3.

M R Beaumont. Alison Wilding. *Arts Review*, 8 May 1987, p301.

M Allthorpe-Guyton. Alison Wilding: Karsten Schubert Ltd, London. *Flash Art*, Oct 1987, p112.

BILL WOODROW

Solo Exhibitions

1972
Whitechapel Art Gallery, London

1979
Künstlerhaus, Hamburg.

1980
The Gallery, Brixton, London.

1981
Galerie Wittenbrink, Regensburg.
Lisson Gallery, London.
LYC Gallery, Brampton, Cumbria.
New 57 Gallery, Edinburgh.

1982
Galerie Eric Fabre, Paris.
Galerie Michele Lachowsky, Antwerp.
Galerie 't Venster, Rotterdam.
Kunstausstellungen, Stuttgart.
Lisson Gallery, London. *Bill Woodrow: sculpture, drawings.* Dupl. typscrpt. 2pp.
Ray Hughes Gallery, Brisbane.
St. Paul's Gallery, Leeds. *Bill Woodrow: sculptures.* Dupl. typscrpt. 1p.

1983
Art & Project, Amsterdam.
Barbara Gladstone Gallery, New York.
Galleria Franco Toselli, Milan.
Lisson Gallery, London.
Locus Solus, Genoa.
Museum of Modern Art, Oxford. *Bill Woodrow: beaver, bomb and fossil.* Illus. cat. 16pp. Text by D Elliott.
Museum van Hedendaagse Kunst, Ghent.

1984
Barbara Gladstone Gallery, New York.
Galerie Paul Maenz, Cologne. *Bill Woodrow: Skulpturen.* Catalogue published in *Galerie Paul Maenz Köln: Ausstellungs–Saison 1983–84.*
Galleria Chisel, Genoa.
Mercer Union, Toronto.
Musée de Toulon. *Bill Woodrow: soupe du jour.* Illus. cat. [36]pp. Text by C Ferbos, M Francis.

1985
Barbara Gladstone Gallery, New York.
Institute of Contemporary Art, Boston.
Kunsthalle Basel, *Bill Woodrow.* Illus. cat. 46pp. Text by J-C Ammann.
La Jolla Museum of Contemporary Art. *Natural produce, an armed response: sculpture by Bill Woodrow.* Illus. cat. 20pp. Text by H M Davies, L Forsha. Travelling to Berkeley.

1986
Butler Gallery, Kilkenny Castle, Kilkenny (Ireland).
Fruitmarket Gallery, Edinburgh. *Bill Woodrow: sculpture 1980–86.* Illus. cat. 144pp. Text by L Cooke.
Galerie Nordenhake, Malmö.
Lisson Gallery, London.
Paul Maenz, Cologne. *Bill Woodrow.* Catalogue published in *Paul Maenz: Ausstellungen: Saison 1985/86.*

1987
Cornerhouse, Manchester. *Bill Woodrow.* Illus. cat [6]pp. Text by G Deslandes.
Kunstverein München, Munich. *Bill Woodrow: positive earth – negative earth.* Illus. cat. 46pp. Text by D Kriegler.
Lisson Gallery, London. *Bill Woodrow.* Dupl typscrpt. 2pp.

1988
Barbara Gladstone Gallery, New York.

Bibliography

T Lawson. Edinburgh: Bill Woodrow, New 57 Gallery. *Artforum*, Dec 1981, p81.

M Newman. Bill Woodrow. *Art Monthly*, Feb 1982, pp19–20.

J Roberts. Car doors & Indians. *ZG* no 6, Apr 1982, 2pp.

C Collier. Bill Woodrow, Lisson Gallery. *Flash Art*, Feb–Mar 1982, pp59–60.

A Cueff. Bill Woodrow: la conduite du matériau. *Artistes*, no 16, June 1983, pp29–34.

M Livingstone. Bill Woodrow at the Lisson. *Artscribe*, no 41, June 1983, pp42–3.

C Collier. Bill Woodrow. *Studio International*, vol 196, no 1000, July 1983, pp10–11.

M Francis. Bill Woodrow: material truths. *Artforum*, Jan 1984, pp34–8.

J McGrath. Bill Woodrow, Roland Brener, Mercer Union. *Vanguard*, May 1984, pp36–7.

R Pokorny. Bill Woodrow, a talk. *Neue Kunst in Europa*, June–Aug 1984, pp10–11.

T Gould. Roland Brener, Bill Woodrow. *Parachute*, no 35, June–Aug 1984, pp 38–40.

L Cooke. B. Woodrow: interview. *Artics*, no 2, Dec 1985–Feb 1986, pp42–9.

K Baker. Bill Woodrow. *Artforum*, Mar 1986, pp125–6.

M Francis. Bill Woodrow: materialets sandheder. *Louisiana Revy*, Mar 1986, pp46–51. Danish text.

L Cooke. Bill Woodrow: The Ship of Fools. *Parkett*, no 12, Mar 1987, pp6–17.

IAIN CHAMBERS studied at the Centre for Contemporary Cultural Studies, Birmingham, and lives in Italy where he teaches at the University of Naples. Author of *Urban Rhythms* (Macmillan, 1985) and *Popular Culture. The metropolitan experience* (Methuen, 1986), he is presently preparing a series of essays on contemporary critical perspectives that will be published with the title *In the slipstream of the world* (Comedia/Methuen).

LYNNE COOKE is an art-historian who teaches at University College, London. A freelance critic, she writes widely on contemporary art.

CHARLES HARRISON studied Art History at Cambridge and the Courtauld Institute. He has been involved with Art and Language since 1970 and is the editor of *Art and Language* magazine. Publications include *English Art and Modernism 1900–1939* (1981), *A Provisional History of Art and Language* (with Fred Orton, 1982), *Modern Art and Modernism* (co-edited with Francis Fraccina, 1982) and *Modernism, Criticism, Realism* (co-edited with Fred Orton, 1984). He is currently Staff Tutor and Reader in the History of Art at the Open University.

MARTIN KUNZ is an Art Historian and Director of the Kunstmuseum, Lucerne. He has curated a number of important exhibitions involving British sculpture, including *Englische Plastik Heute – British Sculpture Now*, 1982.

Views expressed in this catalogue are the author's and are not
necessarily those of the Tate Gallery.

ISBN 0 946590 93 1

Published by order of the Trustees 1988 for the exhibition of
28 May–4 September 1988